HOLDING ON
WHEN YOU
WANT TO
LET GO

HOLDING ON WHEN YOU WANT TO LET GO

Clinging to Hope When Life Is Falling Apart

SHEILA WALSH

BakerBooks
a division of Baker Publishing Group
Grand Rapids, Michigan

Published by Baker Books
a division of Baker Publishing Group
PO Box 6287, Grand Rapids, MI 49516-6287
www.bakerbooks.com

Printed in the United States of America

Library of Congress Cataloging-in-Publication Data
Names: Walsh, Sheila, 1956– author.
Title: Holding on when you want to let go : clinging to hope when life is falling apart / Sheila Walsh.
Description: Grand Rapids, MI: Baker Books, a division of Baker Publishing Group, [2021] | Includes bibliographical references.
Identifiers: LCCN 2021009306 | ISBN 9780801078040 (cloth) | ISBN 9781493432899 (ebook)
Subjects: LCSH: Hope—Religious aspects—Christianity. | Trust in God—Christianity. | Providence and government of God—Christianity. | Miracles.
Classification: LCC BV4638 .W355 2021 | DDC 234/.25—dc23
LC record available at https://lccn.loc.gov/2021009306

ISBN 978-0-8010-7805-7 (ITPE)

The author is represented by Dupree Miller and Associates, a global literary agency. www.dupreemiller.com

21 22 23 24 25 26 27 7 6 5 4 3 2 1

Contents

Introduction

IT ALL STARTED with a magazine article and a question: "Can you tell your story in six words?" Seemed impossible, but I had a three-hour flight, so I thought, *Why not?*

Scottish
wife
mom
clumsy
dogs
Jesus

I looked at the words on the page. All I had was a Scottish wife and mother who falls over her dogs and loves Jesus. Hardly an autobiography.

I dug a little deeper. Where do I start? How do I bring together the pain, the disappointment, the joy, the questions, and tie everything up neatly with a little six-word bow? Not possible. I put down my pencil and stared out the window at the thick, puffy clouds. As I thought back over the years, if I was brutally honest with myself, my life had not turned out as I'd expected.

At twenty-one or even thirty-one, life looked fairly straight-forward, a clean line, simple. I thought I had the right answers to most things life can throw at us. But somehow those easy answers that had worked when I was younger felt hollow with the passing years, and instead of straight lines, what I saw were circles, coming back over and over to the same place, demanding more authentic answers.

I thought of how I'd pictured my "perfect" life when I was young and naive.

I'd be 5'7".

I'd have long blonde hair.

I'd have glowing skin.

I'd be graceful.

I'd be the popular, gifted, athletic girl in school.

I'd have the kind of laugh that sparkled and drew people in.

Instead,

I'm 5'3" (and shrinking).

I have more gray hair than blonde.

I put concealer on with a trowel.

I trip and fall on most days ending with a *y*.

I was chosen last for every sport known to man.

I laugh like a horse.

Clearly not what I expected.

I'm sure we all have a silly list like this, but these are not the disappointing things that shape our lives. There are moments and events that we did not see coming, and we're not prepared for them.

What about you? When you think about your story, are you living the life you imagined? Perhaps some days, when you have time to

take a deep breath, you hardly recognize yourself in the mirror and you wonder, *What happened?* When life takes unexpected turns, it's easy to feel as if everything is out of control; you feel alone, afraid. When God seems silent, do you wonder if you've messed up?

Or perhaps it's more like that infuriating feeling you get when you've spent hours putting a jigsaw puzzle together only to discover that a couple of pieces are missing. You search under the rugs, in the dog's mouth. You threaten your entire family with no food for a week if they're hiding the pieces, but they're gone.

However, I'm learning that the missing pieces in our lives are not gone forever. They reappear at unexpected moments, and even when it hurts for them to be put back in place, the picture is so much clearer when they are.

I was in the middle of a fun FaceTime call with my twenty-three-year-old son, Christian, when the conversation took an unexpected turn. He told me that he's been dealing with nightmares. I asked him about the nightmares, and he told me that the central theme and the overwhelming feeling he is left with when he wakes up is abandonment. He's an only child, and I know that the thought of my husband, Barry, and me being gone someday is a hard one. But there was more going on here. Even as he talked, I recognized the circle he was drawing, and it was coming right back to me. There is a brokenness in me that has cast its shadow on our son.

After my father's death by suicide, I became hypervigilant about how other people were feeling. If you walked into a room, I could have told you how you were feeling, but not how I was feeling because . . . I wasn't. I remember a night when I was about eleven years old. I got up in the middle of the night to use the bathroom. Seeing the light on underneath my mother's bedroom door, I decided to go in, until something stopped me. She was crying. I had no memory of ever hearing my mother cry. I instinctively knew she would not want me to come in, so I sat down on the other side of her bedroom door and cried too. That night I made an unconscious vow. I vowed that

I would never love anyone so much that if I lost them, I would have to weep alone for the rest of my life.

I realized that one of the circles I'd drawn was really a wall I'd built around my heart to keep me safe. I remember climbing on the ruins of an ancient Scottish castle near my home when I was a child. There was something about the missing pieces of the walls and turrets that spoke to me. This was not the castle of princesses, it was the castle for those who lived in the ruins of what was. I have always identified with lonely places. Talking this through with Christian and Barry was one of the most difficult and liberating conversations I have ever had. I've always been there for Christian; it's just that not all of me was always available. Somehow, in those early formative years, he had felt a distance. That night, as we talked and tears poured down my face, I felt God place a sacred piece back into the puzzle of my life, reminding me that it's okay to be vulnerable because God is holding on to me, and I am holding on to Him.

I am still learning how to be healed and whole and to trust God with the still-missing pieces of my life, and my son's, because He is still writing our stories. He is still writing yours too. The pieces are not lost. You are not forgotten, overlooked, pushed aside. Your story is simply not finished yet. We all wish we were able to be the perfect parents, partners, friends, to never bruise another soul. But we are flawed, and that's why each one of us needs the Father.

Every morning I take my Bible and a cup of coffee out onto the balcony of our townhouse. I read three psalms and a chapter from Proverbs. The morning after the conversation with our son, I sat outside in silence. As I sat there, a memory came to my mind. It was so vivid, as if I was watching a movie, but I was in the movie and so was our son. It was late at night, and we were flying home through the Chicago airport. Christian was about four years old, marching ahead of me wearing his Thomas the Tank Engine backpack. Suddenly, he stopped. I was just a few steps behind, and when I reached

Life does not give us a quick fix, but God is always moving, always working.

him, he didn't say a word. He just lifted up his arms. He didn't need to say a word because I heard him.

Mommy, I'm tired.

I bent down and picked him up and held him close. I remembered that night so clearly, even as the picture faded away and it was just me in the morning sun on the balcony. I sat for a few moments in the quiet, and then I stood up, put my Bible down on my chair, and lifted up my arms. I have raised my arms in worship before, but this was different. I was a child needing her Father. I didn't say a word. I didn't have to. I felt held.

I have no idea what's going on in your life as you read these words. What I do know is that we will all face challenges, heartaches, things we didn't see coming. There will be moments when we wish we could rewrite chapters of our stories. But as I began to dig deep into God's Word in past weeks and months, I saw in a way I've never understood before that God has been writing our stories from the very beginning. Life is not out of control, even when it feels as if it is. I promise you that. You are being held, and God is tenderly holding your missing pieces.

I now read stories I've known since I was a child in Sunday school with fresh eyes. Men and women who were at the end of themselves—no hope, no strength—but God was still writing their stories. He was with them, and they were not abandoned, and neither are you.

I still go outside every morning and raise my arms up high; doing so lifts my heart. I turn my face to the heavens, and I am held.

I feel so passionately about the message of this book. Life does not give us a quick fix, but God is always moving, always working. I see this now in ways I've never understood before.

As I've watched God place missing puzzle pieces into the lives of His children in Scripture, each one seems like a miracle. I hesitate to use that word, as we tend to associate a miracle with something that happens in a moment or we doubt that miracles still happen

at all. But I believe in miracles now more than ever. They happen in God's time and with them comes hope. So let's take this journey together. No matter where you are as we begin, I'm praying that by the power of the Holy Spirit, you will hold on.

I have a six-word story now, and it became this book.

Hold on and don't let go.

But Jesus replied, "My Father is always working, and so am I." (John 5:17)

1

Holding On When Life Feels Out of Control

I sat there in despair, my spirit draining away,
 my heart heavy, like lead.
I remembered the old days,
 went over all you've done,
 pondered the ways you've worked,
Stretched out my hands to you,
 as thirsty for you as a desert thirsty for rain.
Hurry with your answer, GOD!
 I'm nearly at the end of my rope.

Psalm 143:4-7 Message

Mental pain is less dramatic than physical pain, but it is more common and also more hard to bear. The frequent attempt to conceal mental pain increases the burden: it is easier to say, "My tooth is aching" than to say, "My heart is broken."

C. S. Lewis

I WAS THIRTY-NINE, PREGNANT, and due to give birth in just over two weeks. I was stupid with happiness. We knew it was a boy

15

and had chosen the name Christian. Barry had followed me around the house for weeks playing worship music to my belly. I think he thought our son would grow up and give Chris Tomlin a run for his money. On the flip side, I was pretty sure our son would come out and punch his dad in the face. "I was trying to sleep in there!"

It was December 12, my last checkup before the big day. I still had two weeks to prepare meals and freeze them. Fourteen days to bask in the glow of being pregnant. Fourteen days of having the best hair and nails of my life. Fourteen days of it just being the two of us and Bentley, our golden retriever. Or at least that's what I thought until my doctor came bounding into the examination room with a big smile on her face.

"Are you ready?" she asked.

"Ready for what?" I replied.

"To welcome your little one into the world," she said. "Let's hit it. It's showtime!"

She seemed so giddy I wondered if she was drunk.

"My due date's not for another two weeks," I reminded her.

"I know that," she said, "but we're going to deliver him today."

"What! Why?" I asked, panic beginning to rise. "He's not done yet, and . . . I have a casserole in the slow cooker!"

"He'll be just fine," she said, scribbling something in my file.

"But why now?" I persisted.

"Well, my husband just surprised me with a golf trip to Hawaii!" she said, clearly expecting me to celebrate with her. I didn't.

"But I'm not dilated at all," I told her. "I couldn't squeeze a grape out, never mind a whole person."

"We have medicine for that," she said in an attempt to assure me and then instructed her nurse to get a wheelchair and take me to the maternity wing of the hospital.

Everything was moving so quickly, and I apparently had no say in the matter.

"Barry! Do something," I cried.

16

Poor man. He just stood there. He looked as if he'd been stunned by a brick.

"I'll drive home and get your go bag," he said, suddenly snapping into action.

"And the car seat," I yelled to his rapidly disappearing back. "And turn off the slow cooker!"

I'm not exactly sure what was injected into my arm, but I don't recommend it. I went from being in no pain at all to immediately feeling as if I was trying to push a donkey through a keyhole. By the time Barry came back, I was in a bad place and I was really scared.

I wanted my mom.

I wanted my sister.

Nothing felt right.

We had talked about the fact that as this might be my only pregnancy due to my age, I was going to go for a natural birth. Rapid change of plan. There was nothing that felt natural about this. I yelled for an epidural and anything else on the cart.

In our minds, Barry and I had written the story of how perfect this was going to be. We had scripted how we thought our little one's entry into the world would go. Chapter 1 of his story would be a little like this: life-giving pain, moments of rest to recharge for the next wave, little slivers of ice, perchance a back rub. Then breathe, push, breathe, push, breathe, push, wonderful, beautiful baby boy.

Well, that was out the window, and we were now officially script-less.

"I think this will help," Barry said in a desperate moment as he pushed play on his boom box. Remember, this was 1996.

As the strains of "Just hear those sleigh bells jingling, ring ting tingling too" filled the room, I thought to myself, *I'm going to wake up in a moment. I'll be home in bed, two weeks to go. This is all just a bad dream.* Everything felt surreal and so out of control, and I was pretty sure I'd never be able to listen to Christmas music again.

17

After twelve hours of the greatest pain I'd ever known, at 5:40 a.m. on December 13, I held my little boy in my arms. He was tiny and perfect.

"Look, Barry," I said, "you can tell we live in California. He came out with a tan."

We both marveled at his "tan" until the doctor informed us that he didn't have a tan; he was jaundiced. He spent a couple of days in the NICU, and then we took our slightly paler baby home.

Chapter 1 of Christian's life was not what we expected, but I knew that God was just beginning to write his story. The circumstances of that day felt very out of control, but they weren't really. I was in a good hospital with a capable doctor (even if her golf clubs were in the corner of the room and she smelled of Coppertone!).

But you know as well as I do that there are situations that don't resolve that easily or that quickly and their endings are far different from what we would write. What do you do then? How do you hold on when everything goes wrong? How do you hold on when life feels totally out of control? Not only that, but how do you keep believing that God is good when life feels bad?

If God . . . Why?

I was challenged on this very "why" question not so long ago. I'd been invited to speak at a women's conference in the Midwest. After the final session, I stayed around for a while to meet some of the women and sign a few books. I noticed that one woman stood off to one side by herself, and I guessed that perhaps she preferred a more private conversation. When the hall cleared out, she came over and introduced herself. She looked troubled, so I asked her if she wanted to sit down. She was quiet for a few moments and then told me that she had a major problem with my final message.

I reflected back for a moment. My last message had been based on one of my favorite chapters in the book of Romans, chapter 8. To me,

it's always seemed like such a beautiful illustration of the love and grace of God. It begins with no condemnation: "So now there is no condemnation for those who belong to Christ Jesus" (v. 1). I love this truth. I've seen it set so many people free who've been weighed down by mistakes from the past. I couldn't imagine that text had troubled her. The last two verses of the chapter end with no separation: "And I am convinced that nothing can ever separate us from God's love. Neither death nor life, neither angels nor demons, neither our fears for today nor our worries about tomorrow—not even the powers of hell can separate us from God's love. No power in the sky above or in the earth below—indeed, nothing in all creation will ever be able to separate us from the love of God that is revealed in Christ Jesus our Lord" (vv. 38–39).

I've always found great comfort in those truths, so I was curious to know how she saw them through the window of her own life. I asked her what it was about my message that bothered her. Sadly, her issue was with the love of God. Her individual story is not mine to share, but I've heard the questions she asked that evening from other lips. Perhaps you've heard them too. Perhaps you've asked them yourself.

If God is a God who is loving, why did this happen?
If God is powerful, why didn't He stop that from happening?
If God . . . why?
If God . . . why?
Why?

I think this is one of the greatest challenges to holding on when life feels out of control. We know that if God wanted to change our circumstances, He could. He could save our marriage. He could heal our child. He could help us get a job. He could help us have a baby. So why would we hold on to the One who could help us if

He doesn't? Will we still love and worship a God we don't always understand? Every single one of us has to wrestle with these questions when life falls apart.

I'm not going to try to give you all the answers here, but let me show you what trusting God looked like up close and personal in the lives of two of my best friends, Brent and Jennalee Trammel.

The Trammels have been our closest friends since we moved to Texas seventeen years ago. We used to live just a few houses down from them, and our boys grew up together. I have so many fond memories of sitting with Jennalee in lawn chairs on the driveway watching the boys on their bikes or their skateboards on summer evenings, taking turns bandaging them up when they attempted a new trick that didn't go well. We used to laugh at the reality that if anything was going to go wrong in any house in the neighborhood, it would be the Trammels' house. Burst pipes, which led to the entire first floor flooding, squirrels in the attic, a refrigerator that worked only when it was in the mood, poison ivy on all three boys at the same time. I used to marvel at Jennalee's resilience. No matter what went wrong, she soldiered on with a smile and this familiar saying: "Someday I'm going to write a book!"

But nothing could have prepared her for what was about to happen just before Christmas in 2010. That December, Brent had a seizure one morning as he was about to take the boys to school. After several tests, the doctors discovered that he had a brain tumor. It was shocking news. Brent was only forty years old. A couple of days after the seizure, Jennalee posted this on her Facebook page:

> Brent had a seizure Monday and long story short is having a brain tumor removed this coming Friday. He is amazing and strong and if you don't believe in God and have faith in Christ, you would from watching my precious husband deal with this. After hearing the news, he looked at me and calmly stated, "Maybe I was created for this very moment."

20

On the morning of his surgery, Brent wrote this note to his boys, which I share with permission:

Chase, Cole, and Tate,

It is very early (4 a.m.) and God is at work! I wanted to just take a few moments to let you know how much I love each one of you! You have each made me the happiest dad in the entire world. I am reminded (in Mark 1:11) when Jesus was baptized out of obedience and respect for HIS Father and an audible voice was heard from the heavens when he came up out of the water. "This is my son, in whom I am well pleased." This morning I now realize the amount of love that a father can have for his sons and all of their accomplishments, victories, and yes even defeats. Therefore, I too echo those words from the mountaintop—"YOU ARE MY SONS, IN WHOM I AM WELL PLEASED!" We were never called to walk a faithless simple life but a life full of abundance and grace that only God can give. This morning, Dad will leave for the hospital without any fear of the unknown, and expect miracles to happen. NO MATTER the outcome of the procedure or the diagnosis, GOD IS IN CONTROL and HE will be praised!

Do me a favor, the next few days will be very difficult for your mom. Pray for her. Love her. Hug her. Obey her. She is truly the love of my life! We will all need each other over the coming days, but she will need you even more over the next few days.

Below is one of my favorite verses:

Romans 8:38–39

"For I am sure that neither death nor life, nor angels nor rulers, nor things present nor things to come, nor powers, nor height nor depth, nor anything else in all creation, will be able to separate us from the love of God in Christ Jesus our Lord" [ESV].

No Fear, Jesus Never Fails,

Dad

He came through the first surgery with flying colors, but his doctor wasn't able to remove all the tumor. It was dormant for some time and then began to grow again. After seventeen months of chemo and radiation, a second surgery was needed, and then gamma knife radiation and a third surgery. The team of doctors left no stone unturned. Throughout the entire painful journey when hope would rise only to fall again, I watched Brent and Jennalee continue to hold on to Jesus, unwavering.

The week before Brent passed, now in hospice care, Jennalee posted this Scripture passage:

> No eye has seen, no ear has heard,
> and no mind has imagined
> what God has prepared
> for those who love him. (1 Cor. 2:9)

When Brent took his final breath on earth, Jennalee simply wrote, "He made it. He's home."

That's what they lived for. He held on all the way home.

What I saw in both Brent and Jennalee was a faith in Christ that lasted over the long haul no matter how out of control things appeared to be. Brent never once in ten years asked, "Why me?"

I think most of us can hold on to Jesus when we walk through something that's hard, but how do we establish the kind of faith that refuses to let go when the battle rages on and on and we are at the very end of our rope? For most of us, that became a very real question in 2020.

At the End of Your Rope

We didn't see it coming. No one did. Somewhere on the other side of the world, a new virus was making people very sick, but it was miles from home. Or at least that's what we thought.

In our home, the Christmas tree was still up. (We hold on to our decorations for as long as we can until one of us cracks and calls time on the festivities.) January was slipping out the door, but still I was reluctant to let go of the sparkling lights and my son's handmade ornaments from when he was a child. Each morning I'd open the back door to let our dogs out and pause at the tree to study them. One of my favorites from fourth grade is of Mary, Joseph, and the baby Jesus made out of clay that had been baked in the school's kiln. The baby is almost as big as Mary. That triggered a few memories.

"We'll need to take the tree down in February," I said to Barry one morning. "Once March hits, my travel schedule is crazy-busy."

That's what I thought at least—and then the bottom fell out of the world and everything familiar and comforting changed. People lost their lives, lost family businesses, lost jobs. School doors were closed, and parents suddenly had to become fifth-grade math teachers. Our churches were locked, and we sat at home binge-watching television shows and gaining fifteen pounds. And for some reason that is still not clear to me, toilet paper became our survival tool. The questions piled on.

God, what's happening?

Do you see us?

Why are you letting this happen?

Will life ever be normal again?

Will we survive this?

When will this be over?

Will our relationships survive this?

Why is everything so out of control?

I don't know how those weeks and months impacted you and your family. It was uncharted territory. We'd never before been in a situation like that in our lifetimes. At first, I honestly enjoyed the

break. I'm used to flying out every weekend to speak, and I'm in the television studio during the week, so for me, living in sweats and not wearing makeup was awesome for a while. I guess I thought the pandemic would last only a few weeks and then we'd all go back to doing what we'd done before we ever heard of COVID-19. But it dragged on and on, and watching the nightly news was heartbreaking. So much pain. So much loss.

As the weeks turned into months, I felt myself spiraling inside. Some mornings I would wake up with such a feeling of dread in the pit of my stomach. It wouldn't lift. It made me feel sick and anxious. All the things I'd learned to help me cope since I'd been diagnosed with severe clinical depression years ago weren't working anymore. I didn't know how to pull myself out of the pit. Some days I just stayed in bed. I would watch our church service online, but I felt a million miles away. Even though I was home with Barry, I felt so alone. I was back in the ruins of the castle.

Then our son contracted the virus. Christian is in graduate school in Houston, and when he FaceTimed to tell us the news, I felt so helpless. Everything in me made me want to drive to Houston and nurse him through it, but self-isolation rules wouldn't let me. Honestly, I wanted to scream, but our fourteen-year-old Bichon Frise, Tink, hates loud noises, so I just cried into my pillow. I was shocked at the level of despair I was feeling. After all these years of trusting God, why did I feel so afraid, so vulnerable?

What do you do when life feels out of control? What do you do when there's nothing you can do? What do you do when you believe that God is good, that God is in control, but nothing makes sense to you anymore? Those feelings can be overwhelming. One of the things I've learned through my depression journey is that when I'm really struggling, it helps me to pray for others. So one evening I went on my Facebook page and simply asked, "How are you doing? Can I pray for you?" I received hundreds of responses, and most of them were heartbreaking.

My husband has lost his job. I don't know how we're going to pay our bills next month.

My dad's in the hospital. He's dying, and they won't let me come to say goodbye.

How am I supposed to homeschool four children and keep my job?

My son committed suicide. I don't know how much longer I can hold on.

My marriage is falling apart, and I don't know what to do.

My children want nothing to do with Jesus anymore. I am brokenhearted.

I'm struggling with anxiety.

Some of the issues were related to the pandemic, but many were simply related to how hard life can be. Some women private messaged me because they said they were ashamed to admit they were struggling.

Let's be honest, sometimes when we're overwhelmed, particularly as Christians, we're tempted to retreat into ourselves. We don't want anyone to judge or shame us. We feel bad enough. Sometimes we don't know how to reach out to others when we're barely holding on. What do we even say? How do we give words to the level of despair we're feeling? As C. S. Lewis wrote, it's easier to say that our tooth is aching than that our heart is broken.

But I know now in a way I've never understood before that when our hearts are broken, we need to be able to say it out loud. If we don't, we sink deeper and deeper into the pit. We need each other. We need to let people into our pain when it is too much to carry by ourselves. We need the companionship of brokenness, of people who love God but don't have all the answers.

When Paul wrote to the church in Galatia, he said this: "Bear one another's burdens, and so fulfill the law of Christ" (Gal. 6:2 ESV).

We need the companionship of brokenness, of people who love God but don't have all the answers.

The Greek word used here for "burden" (*baros*) literally means "a heavy weight or stone someone is required to carry for a long distance." You and I were not designed to carry heavy weights for a long distance by ourselves. When life becomes too much, when everything feels out of control, we need the humility to ask for help, for prayers, to let others know that the weight is too much. That's what I saw in Brent's and Jennalee's lives. They knew that the stone they were carrying was far too heavy to carry alone, even though they had no idea at the beginning how long they would be called to carry it.

As my own despair grew, it brought me to my knees. I've had a Bible since I was a child. I've read it, studied it, memorized it, and taught it, but I began to dive in as if my life depended on it, because it did. I needed to understand the bigger picture of the story God is writing. Day after day, week after week, I sat out on our balcony with my Bible and a notebook and pencil and asked the Holy Spirit to help me see what I might miss. And He did. The stories were right there in the pages, story after story of people who loved God but felt as if their lives were out of control. Story after story of those who were tempted to let go because they couldn't see any way out. But God was with them, every moment, every day. Not only that, but as I studied, I saw that Jesus was there. He is there from the first chapter of Genesis until the final chapter of Revelation. It's always been about Jesus. There has always been a plan. He has always been writing our stories.

God Is in Control

Let's take it right back to the beginning. After Adam and Eve listened to the serpent and disobeyed God, it looked like the whole world had spun out of control. Everything was ruined. Nothing was perfect anymore. Everything seemed lost. But right there in the first few pages of God's Word, we read what's called the *protoevangelium*, the first announcement of the gospel. It's in Genesis 3. God spoke

to the serpent and said, "I will cause hostility between you and the woman, and between your offspring and her offspring. He will strike your head, and you will strike his heel" (v. 15).

From the descendants of the woman who had fallen for the lies of the enemy would come our Savior, Jesus. Yes, Christ's heels would be bruised on the cross, but He would rise again, defeating death and the grave and crushing Satan's head for eternity.

Or think of Noah. When God told him to build a boat, doing so would have made no sense. Many theologians believe that up until that moment in history, it had never rained before, so why was he being asked to build a boat? Not only that, but what was a boat? Once Noah, his family, and the animals were tucked inside, the sky let loose and it rained and the flood came. How were they supposed to survive? There was no dry land anymore. They couldn't live in a boat forever! Everything looked out of control, but it wasn't.

What about Joseph? He was attacked by his brothers, trafficked into Egypt, and eventually thrown into prison. His life was out of control in every way that would make sense to us, but it wasn't. The final pieces in his puzzle are amazing.

Abraham, Moses—they both had stories that made no sense for years. Abraham was told to leave his homeland and everything he knew for a promise that wouldn't be fulfilled until his old age. And Moses tended sheep for forty years before God called him to free the Israelites from slavery.

And what about the children of Israel? Think about how they must have felt when they were halfway across the Red Sea with huge walls of water on each side and a furious army on horses and chariots right behind them. Try to put yourself there. If you remember the end of the story found in Exodus 14, you know that they made it all the way across safely. But when they were just halfway through, it must have been terrifying.

Think about King David. We love the psalms, but half of them were written when he was in the middle of something terrible.

Save me, O God,
 for the floodwaters are up to my neck.
Deeper and deeper I sink into the mire;
 I can't find a foothold.
I am in deep water,
 and the floods overwhelm me.
I am exhausted from crying for help;
 my throat is parched.
My eyes are swollen with weeping,
 waiting for my God to help me. (Ps. 69:1–3)

Those don't read like the words of a man who feels like everything is under control.

Or think about the man whose story we find in Luke 23:32–43. He is a man on death row awaiting execution in the morning. Try to put yourself in his shoes. You're going to die today. There's nothing that can stop that. The final moments of his story are radical.

On and on I read. I read until tears poured down my cheeks and I raised my arms in worship. The Bible is full of story after story of men and women just like you and me who found themselves in situations that felt completely out of control. But God was with these men and women. Not only that, but He held all the missing pieces to their stories.

So right here in chapter 1, I'm asking if you're willing to take a deeper look with me and get a bigger picture of who God is, who we are, and see that no matter how we feel, our lives are not out of control. They may be out of comfort at times, we may be out of answers, we may be filled with pain, but our lives are not out of control.

But here's the irony. Are you ready for this?

They never were under our control.

That dread in the pit of my stomach.

Having a baby at thirty-nine when my doctor was halfway out the door to board a plane to Hawaii.

Nothing was
or ever has
been out of
God's control.
God has always
been in control.

Every single thing I was trying to control was out of my control. The truth is they had never been in my control, but the greater truth is this: nothing was or ever has been out of God's control. God has always been in control. That's what made me raise my arms up to my Father. I finally made peace with that truth and surrendered everything.

The Scripture passage that had been a lifeline for me so many years before became a lifeline again.

> Yet I am confident I will see the LORD's goodness
>> while I am here in the land of the living.
> Wait patiently for the LORD.
>> Be brave and courageous.
>> Yes, wait patiently for the LORD. (Ps. 27:13–14)

So I hold on. Will you hold on too?

HOLDING ON
TO HOPE

1. We were not made to do life on our own; we need to let people into our stories.

2. Jesus is still writing your story, and He holds all the pieces.

3. No matter how things appear, God is in control.

Father God,
When my life feels out of control,
I choose to hold on to You.
Amen.

2

Holding On When
You Feel Alone

O LORD, how long will you forget me? Forever?
How long will you look the other way?

<div align="right">Psalm 13:1</div>

Loneliness comes over us sometimes as a sudden tide. It is one of the
terms of our humanness, and, in a sense, therefore, incurable. Yet I
have found peace in my loneliest times not only through acceptance
of the situation, but through making it an offering to God, who can
transfigure it into something for the good of others.

<div align="right">Elisabeth Elliot</div>

EVERY SEPTEMBER the fair came to our little town on the west
coast of Scotland. It was the highlight of my year. It would open
on a Friday night, and after school on Wednesday and Thursday,
I'd sit at the edge of the field and watch them set up. To a pale, shy
Scottish girl, the fair workers seemed exotic with their long dark
hair and tanned skin. Looking back on it now, the fair was quite a
meager offering, but when you're thirteen years old, the bright lights

and blaring music from the rides and the smell of toffee apples and cotton candy in the crisp fall are intoxicating.

Most of the rides were pretty basic. They were composed of things that spun around very fast and made you question your decision to stuff your face with deep-fried doughnuts as you waited in line. Around the perimeter of the field were attractions like the Hall of Mirrors, where you could appear to be ten feet tall and as thin as a stick or as short and fat as Jabba the Hutt.

I loved everything about the fair, but each year I had one goal in mind. I approached it as a sacred quest. I wanted to win a goldfish. While my sister and brother lined up to ride the rides a second time, I took what was left of my allowance and made my way to the Win-A-Goldfish tent. Winning a goldfish was pretty hard to do. You had to get a Ping-Pong ball into one of thirty goldfish bowls on a table in the middle of the tent. If a ball went in and then bounced back out again, it didn't count. I threw ball after ball each year, watching them bounce off the edges of the bowls and onto the grass below until finally a ball went in and stayed. Then I'd be presented with my fish in a clear plastic bag with a couple of air holes punched in the top. I was over the moon.

Walking home, I would hold on tightly to my fish, trying to think of the perfect name. Most years I settled on Goldie, but one year, because my fish had a black fin, I called him Goldie the Danger Shark. They never lived very long, but I loved them. Every year my sister would remind me of the fact that it would have been cheaper to buy a goldfish than to spend my allowance trying to win one. She totally missed the point that it was the challenge of winning the fish for myself that made the quest so exhilarating.

There was something about watching the fish swim around inside the bowl that fascinated me. I could put my hand on the outside of the glass as it swam past, but it was safe inside. No one could harm it. Something about that subconsciously resonated with me.

I didn't think about that much again until our son had his own fish, a scarlet Betta that he aptly named Red. One morning when I

34

was fixing breakfast, I saw that Red was floating on top of the water. I knew Christian would be devastated, so I came up with a plan. After speaking a few words of remembrance and one verse of "Amazing Grace" over Red, I flushed him down the toilet. Then I wrote a note, put it in an envelope with Christian's name on the front, and placed it beside the bowl. When Christian came downstairs and saw the empty bowl, he asked me, "Mom, where's Red?" I told him I didn't know. (Well . . . do you know where a flushed fish goes? I certainly didn't.) I pointed out that there was a note with his name on it, and he asked me to read it to him.

Dear Christian,

I have loved living with you. You're very funny and very kind, but I just got an offer to join the fish circus in New York. It felt like too big of an opportunity to pass up. I hope you understand, and if you ever make it to the Big Apple, please come and see the show.

Your loving fish,
Red

Christian was quiet for a few moments, then he looked at me with his big brown eyes and said, "I knew that fish would make it big one day." (Several years later on a trip to New York, he said with a big grin on his face, "Hey, Mom, want to go and see Red in the circus?" I guess he'd worked it out by then.)

Another Puzzle Piece

As I was cleaning out Red's bowl that day, I caught my reflection in the little glass tower Christian had placed inside so that Red had a place to hide. I felt a wave of sadness wash over me. I knew it wasn't because of the demise of the fish. There was something about the

bowl that set off a little warning bell inside me. Instead of paying attention to the tolling, I ignored it and placed the bowl on the shelf in the garage that held the former homes of several of Christian's little pets—lizards, frogs, crickets. Over the years, we have housed half the plagues of Egypt.

It took the long months of isolation in 2020 for me to finally pay attention to that rumble in my soul and put a missing puzzle piece in place. As the weeks turned to months, I became aware of the fact that one of the hardest things about lockdown for many people was being alone for the first time. I heard it on the news; I read it on my social media channels. People were lonely, missing being able to be with close friends, being able to hug one another. Although I missed our son, I wasn't experiencing the ache many were. Then I realized why.

I always feel alone.

I always have.

Being alone and feeling alone are not the same things. Being alone can be a beautiful thing, a time of rest, of reflection, of quiet. Feeling alone is a strange thing. You can be in a crowd and feel alone. You can be loved and feel alone. Feeling alone is like a silent ache, a feeling that you don't belong, you don't fit in, you're not like everyone else. Feeling alone doesn't need to make sense; it just is. It's a gnawing ache inside. It's like a piece is missing from your soul.

Even when I'm with the people I love the most, part of me feels alone. Since I was a child, more specifically, since my father's death, I've felt like a fish in a bowl, able to see out but safe inside. I don't think I consciously chose to step inside the bowl. I had simply lost any concept of what normal was or what normal should feel like, and it felt safer to live behind a wall, albeit a glass one.

I don't know whether it was the fact that we were Scottish and not as prone to share our deepest feelings or if it was simply the way our family chose to tell—or rather not tell—our story that left me with questions about myself. Wondering what people were thinking. After my father suffered a brain aneurysm, he took his

rage out on me and not my sister or brother. He would pull my hair, spit on me, slap my face, and it all came to a head on his last day in our home when I fought back and pulled his cane from him. He lost his balance and fell, roaring like an animal. When my mum saw what was happening, she called 911 (999 in Scotland). He was taken away that day to our local psychiatric hospital, but he escaped one night and drowned himself in the river. I had so many unspoken questions.

Why did my father hate me?

Why did he take his anger out on me?

Why would he rather die than be my dad?

Did my mum blame me for his rage?

Did my sister and brother blame me because they lost their dad?

My much bigger question was this: Could everyone else see that there was something wrong with me but no one wanted to tell me?

Would it be better for everyone if I was no longer here?

Part of me wanted to ask the questions, but a bigger part was terrified of the answers. As I think about that little girl now, my heart aches. She was trying so hard to hold on, to hold everything together when it seemed as if everything was falling apart. I know there were many times when she wanted to let go.

She felt like she didn't measure up.

She felt like she was not enough.

She felt like she was tolerated rather than welcomed.

She felt deep down there was something wrong with her.

She looked at others who seemed happy and together, and she
knew she'd never be like that.

I wonder if you've ever been there too.

When something happens to you as a child, and as far as you know it didn't happen to anyone else in the family, you are separated by

circumstance. You stand alone and everyone else stands together, at least that's how it feels.

I have talked to so many women who experienced sexual or physical abuse as children. The fallout from that devastating experience can last a lifetime, and few talk about the loneliness it brings and the "What's wrong with me?" questions.

It's not just abuse that can create that ache; it's any significant pain. Every time you look in the mirror, you wonder, you question. At night when you can't sleep, no one sees the tears that flow.

Some days I think I've come a long way from the little girl who had nightmares every night, who hid in her bedroom when her uncles or church deacons came to visit her mom. Some days are harder than others. On the darker days, I feel more broken than ever.

How Long?

Whenever I'm struggling, I open my Bible. I'm sure that sounds very basic to you, but for me, it's life and breath, not because I find easy answers but because I find myself. In all my times of self-doubt, of insecurity, I anchor myself to the Word of God, and I remember that I'm not alone even when I feel like I am. Feelings can be powerful liars.

Some of David's most vulnerable psalms, the ones that bring comfort and hope, were written when he felt most alone and abandoned, not only by friends but by God Himself. In Psalm 13, he writes,

> O LORD, how long will you forget me? Forever?
> How long will you look the other way?
> How long must I struggle with anguish in my soul,
> with sorrow in my heart every day?
> How long will my enemy have the upper hand?
> Turn and answer me, O LORD my God!
> Restore the sparkle to my eyes, or I will die. (vv. 1–3)

I've probably read that psalm a hundred times, but what struck me recently was the fact that even though David feels as if God has forgotten him, that's who he takes his complaint, his cry, his pain to. He's exhausted and depressed, he's been on the run from King Saul, who wants to kill him, and David is simply at the end of his rope. He doesn't want God to help him tomorrow. He needs help and he needs it now. In his desperation, feeling so alone, he cries out to God.

> Turn to me and have mercy,
> for I am alone and in deep distress.
> My problems go from bad to worse.
> Oh, save me from them all! (Ps 25:16–17)

When we're in such a lonely place, when we keep crying out to God and do not receive an answer, it only exacerbates the pain of feeling alone. We've all been there at one time or another. We cry out when

a child is sick

a coworker is making life unbearable

a financial mess is completely out of control

a son or daughter is in trouble

I am grateful that David didn't try to hide the many times he felt desperately alone in the Psalms. When he writes about his "deep distress," I get that. I know you do too. It's one thing if you're praying for a parking spot at the mall; it's quite another when what you're feeling is overwhelming:

anxious

fearful

depressed

hopeless

sad

alone

With David, we cry out, "How long? How long? How long? How long?" Like David, we feel as if God has forgotten where we live or, perhaps even worse, has turned and looked the other way.

When You're Crying Out in Pain

That pattern of desperately repeating the same cry over and over is also found in one of the most intensely pain-filled passages of Scripture. And again, the cry is taken to God. I have written about this passage before, but in this season, I've seen things I'd never noticed. In Mark's Gospel, we read this:

> They went to the olive grove called Gethsemane, and Jesus said, "Sit here while I go and pray." He took Peter, James, and John with him, and he became deeply troubled and distressed. He told them, "My soul is crushed with grief to the point of death. Stay here and keep watch with me."
>
> He went on a little farther and fell to the ground. He prayed that, if it were possible, the awful hour awaiting him might pass him by. "Abba, Father," he cried out, "everything is possible for you. Please take this cup of suffering away from me. Yet I want your will to be done, not mine."
>
> Then he returned and found the disciples asleep. He said to Peter, "Simon, are you asleep? Couldn't you watch with me even one hour? Keep watch and pray, so that you will not give in to temptation. For the spirit is willing, but the body is weak."
>
> Then Jesus left them again and prayed the same prayer as before. When he returned to them again, he found them sleeping, for they couldn't keep their eyes open. And they didn't know what to say.

When he returned to them the third time, he said, "Go ahead and sleep. Have your rest. But no—the time has come. The Son of Man is betrayed into the hands of sinners." (14:32–41)

Would you pause here and read that passage again? So often we rush over some of the most familiar passages of Scripture because we think, *I know that passage. I know how it ends.* Christ had to live through that night, every minute of every hour. Will you for a moment be with Christ in that garden of desperate tears? He knew that He was in the will of His Father, but in His humanity He knelt alone. Even His closest friends couldn't stay awake with Him. Have you ever noticed that when you're feeling alone, it's much more intense at night? I think of Jesus, in the darkness of the olive grove, the only light from the moon, about to face the unthinkable.

Judas knew where to direct the soldiers, indicating that Jesus often went to this olive grove to pray. There were no gardens inside the walls of Jerusalem. Gardens required fertilization, and that was not allowed in the holy city; it was unclean. A friend must have invited Jesus into the privacy of his olive grove.

The fact that when Jesus prayed, He referred to His father as "Abba," an intimate Aramaic word for "Dad," is weighty to me. It's the only time in all four Gospels that we hear Jesus using this most personal name. Christ knew the devastation that awaited Him. He knew how brutal and cruel death by crucifixion was, and yet He used the most intimate and familiar term to talk to His Father. He didn't address Him as Almighty God; He didn't call Him Father. Rather, in His pain, kneeling alone in the garden, He called Him Papa. He held on. When His humanity must have screamed to let go, He held on.

One of my favorite authors when I was in my twenties was the English writer Thomas Hardy. My favorite book of his was *Tess of the d'Urbervilles*, the story of a young woman who found herself in a set of hopeless circumstances because of the evil of others. Every person who should have spoken up for her or defended her simply

abandoned her. In the end, she was crying out in pain, all alone. At the conclusion of her tragic tale, she loses her life. One of Hardy's final lines in the book is this: "'Justice' was done and the President of the Immortals had finished his sport with Tess."[1] The first time I read the book and got to that line, I threw the book across the bedroom. The whole story was so unfair, so wrong, and no one stepped in to help her. Hardy's conclusion is that the gods just mess with people. That is not the God you and I serve. Jesus knew, even as He knelt in the garden with all that lay ahead, that His Father doesn't mess with people. God doesn't toy with us. Even when we can't always see the plan, He is still our Abba, there is a plan, and we are never, ever alone, even when it feels as if we are.

I am so grateful that Christ allowed us into this moment of His agony, His questions, His loneliness. Just as our fall from grace began in a garden (the garden of Eden), so Christ, the second Adam, would place a missing piece in our rescue story in a garden. The garden of Gethsemane is a grove of olive trees located at the foot of the Mount of Olives, just about half a mile outside Jerusalem. The word *Gethsemane* comes from the Aramaic word meaning "oil press." Christ was about to be crushed just as olives are. I learned from *The Rock, The Road, and the Rabbi* (a book messianic rabbi Jason Sobel cowrote with my friend Kathy Lee Gifford) that olives go through three pressings to extract every drop of oil. "The three pressings of the olives are connected to the three times Jesus asked His heavenly Father to 'let this cup pass from Me.'"[2] Christ was crushed in the garden, returning to the tear-and-blood-soaked ground three times to cry out in agony. Luke, the doctor, lets us know that Christ was in such agony that he sweat drops of blood (Luke 22:44).

When you find yourself in a place where you are crying out in pain, begging God to listen to your prayer, to change your situation, to intervene in the way only He can and He doesn't, just know that Christ has been there too. There is nothing you and I will face that Christ has not already faced. He has felt the weight of our pain. He

We are never,
ever alone,
even when it feels
as if we are.

knows what it is like to feel all alone. When He was crucified, He knew that at a depth we never will.

This would be the only time in history that Christ, the Son of God, would be separated from His Father as He took the sin of the world on Himself and His Father turned away. The Son of God was all alone. Agony.

The Lies of Loneliness

I think one of the hardest things to bear when you're in a lonely place is being misunderstood. It can feel like a knife in your chest.

For twenty years, I was part of a team of women speakers and teachers called Women of Faith. It was an amazing season speaking at full sports arenas up to thirty weekends each year. There were six of us on the original team, and we stayed together through the final tour. We were like family. Christian was just six weeks old at the first conference, so he grew up in the company of these fabulous women. When six women with different temperaments, weaknesses, and strengths are together for twenty years, there will be moments that require smoothing out. Amazingly, those moments were few. We really loved and supported one another. We laughed a lot and shed some tears, but one situation wounded me and left me feeling alone. If only I had spoken up, it would have been resolved in a minute, but I didn't. That's what shame does.

Shame can silence us when speaking up would set us free.

Shame tells us we won't be understood.

Shame tells us we're not worth speaking up for.

Shame is a liar.

God's Word holds the truth.

As a team, we worked with an organization that sponsors children in different parts of the world, and we were invited to take a trip to one of the projects we had been working with in Africa to get a greater understanding of their work. A couple of weeks before the

trip while we were looking through the itinerary, we discovered that we'd have two free days at the end before we flew home. Everyone was excited about the possibility of seeing some of the beauty of Africa. We decided that as long as we were all in agreement, we would travel to a game reserve a few hours away from base, stay there for two nights, and travel home from there. Obviously, we'd be responsible for paying for that part of the trip ourselves. It was quite expensive, but everyone felt it was well worth it to be able to see lions, elephants, and hippos in their natural habitat. Everyone said they were on board, but when it was my turn to answer, I said I couldn't go. No one expected that response from me, as I was usually up for any adventure. If I didn't go, the whole thing was off. They were understandably frustrated with me. When I wouldn't explain why, they became upset.

What I didn't tell them that day was that Barry and I were having some financial troubles. A few months earlier, we'd purchased a new home just one day before the sale of our old one was supposed to be finalized. Then the housing market collapsed, and the sale of our old house fell through at the last minute, leaving us with two houses to pay for. We were struggling.

All my old feelings of insecurity and self-loathing raged to the surface. After my father's death, we lost our family home and lived just above the poverty line. I had worn that experience like a label, imagining that everyone could see it. Now even as a grown woman in a community of women who loved me, I couldn't make myself reach over the edge of the fishbowl I'd fallen back into and tell the truth. I remember excusing myself and finding a quiet restroom in the back of the arena and just sobbing. All the lies of loneliness played over and over in my head.

You're not enough.

You don't fit in.

You don't belong.

You'll never be like everyone else.

The team would be better off without you.

I remember looking at my watch and realizing that the event was about to begin, so I dried my eyes and removed as much of the mascara off my cheeks as I could. I headed out into the arena and took my seat. I was in a crowd of seventeen thousand women, but I felt so alone. I was part of a close-knit team of six women, but I felt alone. I felt misunderstood, but I wasn't. I'd never opened up and told them what was going on. Imagining their rejection, I had rejected them.

I remember looking around the arena that night and wondering how many women felt alone too. We are quite skilled at cleaning ourselves up and putting on a brave face when often just below the surface, we are in pain.

Later that weekend, I spoke to Barry about the trip, and he made a way for it to happen. But I still didn't tell the others what had been going on with me. I almost backed out on the way to the airport to catch my flight to Johannesburg, then on to Nairobi. I imagined that they were still a little annoyed with me for potentially ruining the final part of the trip.

When insecurity and fear are tied in with unresolved childhood pain, we put up barricades, we isolate ourselves, we hide in fishbowls of our own making. We imagine what others are thinking when they are often not thinking about us at all.

When I'm writing a book, I often wish I could sit down with each woman who reads it. I would love to have a cup of tea with you and hear your story. What's the path that has brought you to where you are right now? Do you struggle with loneliness? What's going on in your life that makes you feel alone?

You can feel alone in a marriage.

You can feel alone in a family.

You can feel alone in a church.

You can feel alone because of illness.

You can simply feel alone.

I believe that no matter what we are facing, God's Word speaks to it. So what does it have to say to us when life falls apart and we feel so alone? Even though I see brokenness in myself and in others, even though there are circumstances in life that don't make sense, I know this: God is good, God is love, God is in control. God's Word is alive and can help us make it all the way home.

Waiting While God Is Working

If you are in one of those situations in life where the "Why?" is greater than you can bear, perhaps you can write down what is happening on a piece of paper, put it in a Mason jar or a box, and trust God with what you don't understand. Writing it down acknowledges that it's true. It is happening, and you are waiting.

That's what I had to do. I mentioned that Barry and I ended up owning two homes. What I didn't say was that we owned two homes for over five years. The financial pressure was overwhelming, mixed in with the guilt of having moved on one home before the other sold. We felt foolish. We were ashamed. We were desperate. We prayed and begged God to help us sell our house. At times, we both felt so alone. Financial pressure puts a strain on the best marriages. We tried to shield Christian from the stress but it would leak out from time to time. Instead of dealing with what was happening together as a couple, Barry and I both retreated to our own self-protective, familiar corners. Barry felt guilty and anxious. I felt insecure and afraid. The emotional circle was taking me right back to my childhood. After my father's death, money was always tight. I hated being back in a place of financial insecurity because of how it made me feel:

Trust God
with what you
don't understand.

alone

different

poor

to be pitied

dripping with shame

Shame is a ravenous beast that tells compelling lies. It tells us that we are alone. It tells us that everything we've wondered about ourselves in our darker moments is true. It tells us that we don't belong. It tells us that it would be better for everyone if we just didn't show up. It put me right back into that blue dress on the night I sat all alone in a field.

Shame and the Blue Dress

I was twelve years old, graduating from what's called primary school in Scotland, and about to go into high school. Everyone in my class was excited about the school dance—everyone but me. I didn't have a party dress, and I knew that my mum, working with a very limited budget, couldn't afford to buy one. I'd made peace with that until I came home from school one afternoon and my mum told me that she'd bought me a dress for the party. I couldn't believe it. I was so excited. She told me that it was lying on my bed, so I ran up the stairs, taking them two at a time. I opened my bedroom door, and there it was: the blue dress. It was all wrong. The fashion that year was short, straight dresses, and this dress had a full skirt, ruffles, and a big, blue satin ribbon that tied in the back. My heart sank. My mum had sacrificed to buy the dress, so I couldn't hurt her feelings, but I knew I couldn't face my school friends wearing that dress. I sat on my bedroom floor and cried. I felt so alone. On the night of the dance, I put on the dress and a big smile and came downstairs. Mum told me that I looked beautiful. I gave her a big hug and thanked her

and headed out the front door. It was a short five-minute walk to my school, but I took the long way around, as I didn't want any of my friends to see me. I sat in the field at the back of the school and watched everyone arrive. All the girls were wearing the right dress. I sat there all night until the dance was over. I don't think I've ever felt so alone in my life. I couldn't tell anyone, not my family and not my friends. I couldn't tell my mum that the dress was all wrong, and I couldn't tell my friends how ashamed I felt. I remember talking to Jesus, holding on to Him for dear life. When the dance was over, I walked home and told my mum that I'd had a wonderful time, and then I cried myself to sleep. I wish now that I'd kept that ugly dress. It used to tell me that I didn't belong. Now I know that's not true—for me or for you. Because of Jesus we belong; we're not alone. We don't have all the answers, and we're not immune from pain, but we belong. No longer lone swimmers in a fishbowl.

One night Barry and I sat down and wrote everything out on paper. We wrote down what we needed, and we wrote down what we had, and we gave it all to God. We asked Him for forgiveness and grace, but more than that, we asked for His presence. There was nothing more we could do, so we waited and waited. Five years is a long time, but we held on to Christ, and we held on to each other. You may have been waiting even longer. What I learned in that painful chapter of our lives is that we never wait alone. We wait in the presence of God, and in that waiting, God is working.

HOLDING ON
TO HOPE

1 · In times of loneliness, anchor yourself to the Word of God.

2 · Shame is a liar, but God's Word holds the truth.

3 · We wait in the presence of God, and in that waiting, God is working.

Father God,
At times, I feel so alone. Thank You that
You are holding me in the waiting time.
Amen.

3

Holding On When
God Is Silent

My God, my God, why have you abandoned me?
Why are you so far away when I groan for help?
Every day I call to you, my God, but you do not answer.
Every night I lift my voice, but I find no relief.

Psalm 22:1–2

The silence of God's voice will make you wonder if He is even there.
And the absence of God's presence will make you wonder if He even
cares. He is. And He does.

Chuck Swindoll

HAVING CONFESSED the loneliness I have dealt with for most of
my life, I have to add that, by nature, I'm an introvert. I love being
with people, but then I love to be alone. Barry is not an introvert.
He loves being with people, and he does not like being alone. Barry
wakes up talking. He falls asleep talking. He talks when I'm reading
a book. He talks during my favorite television shows. He is the con-
summate chatty extrovert. Somehow over the years, we've made our
differing chemistries work. It was tough at first. I like to curl up with

a good book and get lost in the story, so the constant interruptions were annoying, particularly when the information delivered didn't seem, how can I put it, urgent.

"I think it's going to start raining in a few hours."

"Do you think cats can smile?"

"I'm going outside to cut my toenails."

"Look at this cute picture of a duck and a donkey."

I can't tell you how many times I've read and reread the same paragraph trying to get back into the narrative of my book. So I came up with a plan.

"Okay, I'm going outside to read for an hour. Do not come out unless the dogs are on fire. I don't mean smoke either. There needs to be flames."

I'm kidding . . . sort of.

Then 2020 hit like a Mack truck, and we were all home, all the time. In our house, it was just the two of us and our two dogs. Tink is a fourteen-year-old Bichon Frise. She is sweet and fairly low maintenance and an introvert like me. She enjoys her space. Maggie is a six-year-old Yorkie who could be described as Barry with a tail. She is a barker. She barks if anyone comes to the door. She barks if anyone walks past our house. She barks if she thinks someone *might* walk past our house. I call that preemptive barking. When she's not barking, she's pawing my leg and talking. I know what she's saying.

"I think it's going to start raining in a few hours."

"Do you think cats can smile?"

"I'm going outside to cut my toenails."

"Look at this cute picture of a duck and a donkey."

Over the years, Barry and I have found a comfortable space with each other. He talks a little less, and I talk a little more. That's the joy of marriage, and with that joy come in-laws. When I first met William and Eleanor, it was clear that their roles were the reverse of ours. William was pretty quiet, and Eleanor was a feisty redhead with a lot to say. I'll never forget having breakfast one morning in

their home in Charleston, South Carolina. Barry was still asleep, so it was just the three of us sitting around the oak table in their kitchen. William warned me about why Eleanor kept thick cushions on each chair. "She thinks if you're more comfortable, you'll listen longer!" Eleanor launched into a fifty-minute breakdown of everyone who had ever attended their small Lutheran church. There were some fascinating characters: some whom she considered good Christians and others who were "frauds in a suit." When she finished, I asked William if he wanted to add anything. All he said was, "The church is in that direction," and he pointed out the window. Pretty typical of their dynamic. I found them both hilarious in their own ways. Eleanor had very particular views on everything from TV preachers to the government to every pastor who had ever stood in the pulpit of their church. But she was silenced when cancer invaded her life.

Not Ready to Say Goodbye

Eleanor was diagnosed with cancer in her midsixties. She begged God to heal her, but heaven seemed silent to her cries. She questioned God's love for her because she wasn't being healed. I remember a conversation we had in the middle of the night not long before her death. She told me that she believed that if I was the one with cancer, God would have healed me. We wept together that night as I assured her that God didn't love me one grain of sand more than He loved her. Then she asked me this question: "Then why doesn't He answer my prayers? I've been praying for so long. I want to be around to see Christian grow up."

We sat in silence for a while. I had no words, though my heart was aching. I began to sing one of her favorite hymns, and she joined in. Her voice was weak, but she was holding on.

> Great is Thy faithfulness, O God my Father;
> There is no shadow of turning with Thee.

Thou changest not, Thy compassions they fail not;
As Thou hast been, Thou forever wilt be.

Great is Thy faithfulness!
Great is Thy faithfulness!
Morning by morning new mercies I see;
All I have needed Thy hand hath provided.
Great is Thy faithfulness, Lord, unto me!

A few days later Eleanor went home to be with Christ, the One who loved her even in the silence. On the day of the viewing, Christian stayed with a friend, as he was only three years old, and William, Barry, and I drove to the funeral home. Eleanor looked like she was asleep. Her hands were folded over her chest. She was wearing the cream-and-gold suit she had worn to our wedding. Her beautiful fiery-red hair that never had a single gray had been pushed a little too far back on her forehead, so I gently pulled it down and into place. My hand brushed against her face. It was so cold. Finally, I pinned a photo of her and Christian, which she'd asked me to place in her casket, on the little satin pillow above her head. "Well done, Mom," I said. "You made it all the way home. You held on."

I wrestled with Eleanor's questions for a long time. Why is heaven silent when we need to hear God's voice? Why would God hold back healing when He can heal? Does He love some of us less than others? Why is He silent when we've never needed to hear His voice more? I also thought back to how silent He was when my mum searched for answers that never came. I struggled with the silence of a loving God. I dug deep into the Scriptures, but many passages that had brought comfort in the past left me feeling more alone than ever.

Finally, after weeks, I found help in what seemed to me to be the least likely place. It's the story of a righteous, godly man who asked a lot of questions and didn't receive one single answer. He wanted answers, but God gave him much more. He gave Himself.

When the Unthinkable Happens

I love the way Philip Yancey sets up Job's story in his book *Disappointment with God*: "It helps to think of the Book of Job as a mystery play, a 'whodunit' detective story. Before the play itself begins, we in the audience get a sneak preview, as if we have showed up early for a press conference in which the director explains his work."[1]

In case Job's story is new to you, here's how this mystery play begins.

Job was a man who lived in Uz. He was honest inside and out, a man of his word, who was totally devoted to God and hated evil with a passion. He had seven sons and three daughters. He was also very wealthy—seven thousand head of sheep, three thousand camels, five hundred teams of oxen, five hundred donkeys, and a huge staff of servants—the most influential man in all the East!

His sons used to take turns hosting parties in their homes, always inviting their three sisters to join them in their merrymaking. When the parties were over, Job would get up early in the morning and sacrifice a burnt offering for each of his children, thinking, "Maybe one of them sinned by defying God inwardly." Job made a habit of this sacrificial atonement, just in case they'd sinned. (Job 1:1–5 Message)

That's quite a résumé. Honest inside and out, totally devoted to God. He's the kind of husband you'd want, the kind of father who looks out for his children, but his life is about to take a devastating turn. Before we look at what actually happened to him, I want to pause and listen to what the director told the audience before tragedy struck.

One day the members of the heavenly court came to present themselves before the LORD, and the Accuser, Satan, came with them. "Where have you come from?" the LORD asked Satan.

Satan answered the LORD, "I have been patrolling the earth, watching everything that's going on."

Then the LORD asked Satan, "Have you noticed my servant Job? He is the finest man in all the earth. He is blameless—a man of complete integrity. He fears God and stays away from evil."

Satan replied to the LORD, "Yes, but Job has good reason to fear God. You have always put a wall of protection around him and his home and his property. You have made him prosper in everything he does. Look how rich he is! But reach out and take away everything he has, and he will surely curse you to your face!"

"All right, you may test him," the LORD said to Satan. "Do whatever you want with everything he possesses, but don't harm him physically." So Satan left the LORD's presence. (Job 1:6–12)

Purely on a human level, this feels like betrayal to me. Why would God do such a thing? Why would He allow Satan to attack a man who loved God with everything in him? Have you ever felt that way? I know I have, particularly regarding my friends Brent and Jennalee. Perhaps you've watched a friend who has gone through one thing after another after another, and you've thrown your hands up in the air and asked, "Why? Why do they have to suffer so much? Where are You, God?"

I'm often asked those kinds of questions, and I have no perfect answers. When someone is suffering and in pain, when they feel as if God has turned His face away, there are no answers big enough to help. In times like those, we don't need answers; we need His presence. We need His peace. We need one another.

As I read Job's story, I found myself reading it with different eyes than when I was younger. I think the older we get, the more empathy we have for others. Suffering washes our eyes to see the weight others are carrying. When we've lost people we love, we feel the loss that others are facing more acutely. I've always seen Job as a man who loved God despite incredible suffering. He was a figure of faith. But this time I saw him not just as a person in the Old Testament but as a real man, a loving husband, a proud father. Job was a man

who had no idea what was about to hit him. Nothing could have prepared him.

Most of us remember where we were on September 11, 2001. It's etched into our collective memory because what happened that day was unthinkable, and the magnitude took our breath away. I'm pretty sure that Job would remember exactly where he was standing when he received the news from his servants because it brought him to his knees as well.

The Worst of Times

> Sometime later, while Job's children were having one of their parties at the home of the oldest son, a messenger came to Job and said, "The oxen were plowing and the donkeys grazing in the field next to us when Sabeans attacked. They stole the animals and killed the field hands. I'm the only one to get out alive and tell you what happened."
>
> While he was still talking, another messenger arrived and said, "Bolts of lightning struck the sheep and the shepherds and fried them—burned them to a crisp. I'm the only one to get out alive and tell you what happened."
>
> While he was still talking, another messenger arrived and said, "Chaldeans coming from three directions raided the camels and massacred the camel drivers. I'm the only one to get out alive and tell you what happened."
>
> While he was still talking, another messenger arrived and said, "Your children were having a party at the home of the oldest brother when a tornado swept in off the desert and struck the house. It collapsed on the young people and they died. I'm the only one to get out alive and tell you what happened."
>
> Job got to his feet, ripped his robe, shaved his head, then fell to the ground and worshiped. (Job 1:13–20 Message)

I can only imagine the cry of agony that must have gone up from Job. I can't fathom that kind of pain. For Job and his wife, I imagine

that day began like any other day. It was a quiet day. Their children were together at their eldest son's house, which made them happy. We love it when our children get along. We love it too when they're off at someone else's house and we can get a bit of peace and quiet. Then the world caved in. It started with someone banging on the front door.

It's like that phone call in the middle of the night that makes your heart sink.

It's like sitting in your doctor's office waiting for the results from your tests. The moment he walks through the door, you can tell by the look on his face that it's the worst possible news.

It's like that moment when you realize that once more you are not going to be able to carry your precious baby to term.

The first servant is out of breath from running to give Job his terrible news. Before Job can even wrap his mind around it, someone else arrives, then another. The final one arrives, I imagine, with tears pouring down his cheeks.

"It was a terrible accident. Your children . . . they're gone. All your children are dead."

In just moments, Job went from being a wealthy man and the father of seven sons and three daughters to having lost everything. How could one human being possibly endure that much pain and live?

Fact or Fiction

I was writing in a favorite coffee shop one day when the man at the table next to mine asked me what I was writing. I told him the title of this book and that the chapter I was working on was about the life of Job.

"You mean the story in the Old Testament?" he asked.

"Yes, that's the one," I said.

"You know that's not a true story," he said. "It's just a story to make a point about how hard life is."

I discovered that he's not alone in questioning whether Job was a real man. If you research that question, you'll discover that many people suggest that the entire book is an allegorical story, a parable to teach us a lesson, like the story of the good Samaritan (Luke 10:25–37) or the prodigal son (Luke 15:11–32). I could not disagree more. Those stories were clearly presented as parables, but not so with Job.

If he was never mentioned anywhere else in the Bible, you might be able to consider that possibility, but Job is referred to twice in Ezekiel, where he is listed with Daniel and Noah, not fictional characters (14:14, 20), and again in the New Testament. In James 5:10–11, we read this: "For examples of patience in suffering, dear brothers and sisters, look at the prophets who spoke in the name of the Lord. We give great honor to those who endure under suffering. For instance, you know about Job, a man of great endurance. You can see how the Lord was kind to him at the end, for the Lord is full of tenderness and mercy."

There is no doubt that Job was a real man who faced real suffering on a level most of us will never approach. Not only that, but he had no idea why this had happened. In the era of the Old Testament, blessing was seen as a sign of God's approval and suffering was seen as a sign of God's judgment. In light of that belief system, how was Job supposed to wrap his mind around this catastrophic loss? He'd done everything right, and everything had gone wrong. When everything you believe about how God works is ripped to pieces before your eyes, what do you do?

What Did I Do Wrong?

I know how desperate the silence of God can feel. For months before I was hospitalized with clinical depression, I just couldn't shake the overwhelming sadness that I was feeling. Every morning when I woke up, I felt as if there was a lead weight on my chest. I wondered how

long I could go on living this way. I was so desperately unhappy. I loved God, but I was miserable. I decided that I needed to show God how serious I was and beg Him to speak to me. If there was something in my life that was blocking me from knowing His peace, I wanted to know what it was. So I did the only thing I knew to do. I took time off work and I fasted and prayed for twenty-one days. Early each morning I would walk along the deserted beach in Virginia where I lived and would cry out to Him.

Father, if there is sin in my life that I'm not aware of, please show me and I'll confess and repent.

If there is someone I need to forgive, please show me.

If there is any bitterness or anger in my heart, please show me.

If there's pride, please show me.

If I have disrespected You in any way, please show me.

Father, please speak to me. Whatever it is, please speak to me. I need to hear Your voice.

I did that for twenty-one days. But God was silent.

No rebuke.

No comfort.

Nothing.

Have you ever been there?

You're struggling financially and just need a word from God. Silence.

Your child is sick and you're begging God for healing. Silence.

You need direction for your life. Silence.

Should I take this job or not, should I move or not? Silence.

Your world is falling apart. Silence.

When days drag into weeks, we wrestle with what we believe to be true. We believe that God is loving and merciful. We believe that He is a God of all comfort. We believe that He cares for us. We believe that He speaks to His people. We believe, and yet we are living with the silence of God. This is why I want us to take a closer look at the silence of God in Job's life. It lasted for a long time, but his story has a surprise ending. The puzzle piece that God put in place for Job took his breath away.

The Battle

Was it surprising to you when you read that Satan was allowed to enter the courtroom of heaven? It was for me the first time I read it. What a bizarre picture. The most evil creature allowed into the presence of the most Holy. Not only was he allowed to be there, but he was also allowed to have a conversation with God and accuse one of God's servants. Did you know that he is still doing that? Until Satan is thrown once and for all into the lake of fire, he is talking to God, accusing you and me and all who love Jesus of being faithless and ready to let go. In the Revelation given to John, we read this: "Then I heard a loud voice shouting across the heavens, 'It has come at last—salvation and power and the Kingdom of our God, and the authority of his Christ. For the accuser of our brothers and sisters has been thrown down to earth—the one who accuses them before our God day and night'" (12:10).

I always thought that when Satan was called the accuser of God's people, it meant that he's always attacking *us* with condemnation. I'm sure that's true, but there is a bigger conversation going on in heaven. In the courtroom of heaven, he is accusing us before God our Father day and night, saying that we're not going to stand firm to the end, that we're going to deny Him, that we're going to walk away from our faith, that we're going to let go. Can you imagine those accusations?

Let her marriage fall apart and she'll curse You!
Let her get sick and she'll curse You!
Let me close the door on that job and she'll curse You!
Let her fall into bankruptcy and she'll curse You!

Fill in the blanks with your own story. Satan is determined to devastate our faith and make us let go of Jesus.

God told Satan that Job was the finest man on earth. Ever the liar and accuser, Satan mocked Job's integrity. "Look how rich he is!" he said. He implied that the only reason Job loved God was because he was the richest man on the planet. Satan's accusation was this: "Take away everything he has and he'll curse You to Your face."

Let me just take a short sidebar here and sit with you. I don't know what you've walked through or are walking through. I don't know what made you pick up this book. I want you to know this: when you are walking through suffering, loss, pain, and grief and you still choose to love God, all of heaven celebrates. When you get down on your knees, albeit with questions on your lips and tears on your cheeks, and worship God, you are being watched and your actions are a wonder to the angels. Even in the silence, you are being held.

It is all so wonderful that even the angels are eagerly watching these things happen. (1 Pet. 1:12)

When Job collapsed on the ground, he had no idea that the hosts of heaven and hell watched to see how he would respond to his devastating loss. He didn't know that Satan had bet against him. I would imagine Satan felt pretty confident in that bet. Not only had Job lost all his wealth, but he would also have to bury his ten children. Having to bury one child is tragic, but losing them all in a moment is unthinkable.

Think about this. Most commentators agree that Job lived before the time of Moses, so he had no law from God, no Genesis, no Scriptures at all. What did he hold on to? How did he know God? Where

64

did he get his faith? That's just part of the wonder of God. He has always been able to reveal Himself to people. The more I studied, the more pieces God began to put in place. He did it for Job, and He is still doing it today. There are many stories coming out of Iran of Christ Himself appearing to people in dreams.

I believe Jesus is walking in the streets of Iran just as He walked through towns and villages all over Israel—it is amazing how thousands of Iranians are coming to know the Lord. The church in Iran is the fastest growing church in the world.[2]

Job's knowledge of God was anchored in whatever God had revealed to him. He loved God, but he never got to experience the part of the story that we know. Job lived before the life, death, and resurrection of Christ. We have so many more pieces of the puzzle available to us than Job did. We are called to live by faith, but Job was called to live by faith at a depth we'll never know.

Hair was seen in biblical times as a man's or woman's glory. Job shaved his head, ripped his robe in grief, and fell to the ground. I imagine him lying facedown, his glory gone. But even in the depth of his grief, he worshiped: "Naked I came from my mother's womb, and naked I will depart. The LORD gave and the LORD has taken away; may the name of the LORD be praised" (Job 1:21 NIV).

He looked back to the moment when he took his first breath. He looked forward to the day when he would take his last, and then he worshiped the Lord. How was he able to do that? I honestly don't have a good answer. God holds that secret. God knew what was in Job, his integrity, his character, or He would never have allowed Satan to do what he did. It must torment the tormentor when we worship even in the midst of what we don't understand.

Satan can't hurt God, so his plan is to hurt how we see God. This is very important. Satan is powerless to impact God, but if he can get us to look at our circumstances, at what we don't understand, and

We worship
even in the
midst of what
we don't
understand.

then question the love of God, he has scored a victory. Questioning the goodness of God is a little victory, but if he can get us to walk away from our faith, he has won a hellish victory. I say, in Jesus's name, no, we will not!

I titled this book *Holding On When You Want to Let Go* because there will be moments when you might be tempted to let go. When you are holding on by a thread. In those moments, say the name of Jesus out loud. Call on the name of the Lord. Remember there is a battle raging over each one of us. It's a battle that will become more intense as Satan's time is running out. Never forget that Jesus, our High Priest, is praying for you and that He who is in you is greater than he who is in the world.

> But because Jesus lives forever, his priesthood lasts forever. Therefore he is able, once and forever, to save those who come to God through him. He lives forever to intercede with God on their behalf. (Heb. 7:24–25)

And never forget that when you can't even utter a word, the Holy Spirit is interceding for you.

> And the Holy Spirit helps us in our weakness. For example, we don't know what God wants us to pray for. But the Holy Spirit prays for us with groanings that cannot be expressed in words. And the Father who knows all hearts knows what the Spirit is saying, for the Spirit pleads for us believers in harmony with God's own will. (Rom. 8:26–27)

The Battle Continues

Job passed his brutal test of faith with flying colors, but his suffering wasn't over. Once more Satan presented himself before God.

> Then GOD said to Satan, "Have you noticed my friend Job? There's no one quite like him, is there—honest and true to his word, totally

devoted to God and hating evil? He still has a firm grip on his integrity! You tried to trick me into destroying him, but it didn't work."

Satan answered, "A human would do anything to save his life. But what do you think would happen if you reached down and took away his health? He'd curse you to your face, that's what."

God said, "All right. Go ahead—you can do what you like with him. But mind you, don't kill him." (Job 2:3–6 Message)

"You can do what you like with him. But mind you, don't kill him."

These are hard words to read. They would be callous words from an enemy, but from God, they hit us hard. We don't know the span of days between the two meetings in heaven, but I imagine it wasn't very long. Satan had lost his first bet, so I'm sure he wanted to hit Job while he was down. He'd been told that he couldn't kill Job, but he took him as close to the edge as possible, and he wasted no time. "So Satan left the Lord's presence, and he struck Job with terrible boils from head to foot" (Job 2:7).

That must have been agony. Can you imagine waking up one morning covered in boils? They're on your scalp, on the soles of your feet. They're covering your back where you can't reach them. We read in Job 2:8 that Job left his palatial home and made his way to the city garbage dump. As he sat among the ashes, he scraped his skin with a piece of broken pottery. He must have been in so much pain.

In his study on the life of Job, Warren Wiersbe helps us imagine the devastating place where Job sat: "There the city garbage was deposited and burned, and there the city's rejects lived, begging alms from whomever passed by. At the ash heap, dogs fought over something to eat, and the city's dung was brought and burned. The city's leading citizen was now living in abject poverty and shame."[3] Chuck Swindoll sums it up perfectly: "In short, Job became 'Ground Zero' in human form."[4]

It was too much for Job's wife. The Bible tells us Job's story, but it's her story too. She was the one who gave birth to those children. She stood by her husband's side and wept over ten mounds of earth. She used to be the first lady of the community, married to the most respected man in the region. Now she's lost everything, including him. It's hard to recognize the broken wretch sitting in the garbage dump. "His wife said to him, 'Are you still trying to maintain your integrity? Curse God and die'" (Job 2:9).

That's what Satan was waiting for. That's what he wanted. I imagine the hosts of heaven and hell watching, waiting. Will he do it? She is greatly criticized in many theological texts for what she said, but part of me understands her despair. Have you ever had to watch someone you love suffer? There are times when human suffering is so bad and the quality of life so poor that we beg God to take a person home. And yet this is different. It wasn't a prayer for relief; it was a giving up of faith. She was saying to Job, "Let go. You've held on long enough. Let go!"

"But Job replied, 'You talk like a foolish woman. Should we accept only good things from the hand of God and never anything bad?' So in all this, Job said nothing wrong" (Job 2:10).

I Have Seen You with My Own Eyes

The book of Job is one of the longest in the Bible. There are some wonderful in-depth commentaries that unpack the entire story. They map out the terrible suffering of an innocent man. They unpack for us the role of Job's friends who came to sit shiva (the act of sitting on low stools during times of mourning) with him for seven days and seven nights before they began to talk. They brought no comfort at all. His friends had a particularly punishing theology. You might have encountered this in your own life.

You are suffering. God is good. Therefore, you must have done something wrong.

It is wonderful to study the entire text, but that's not my purpose here. There is just one thing I want us to hold on to in the midst of the following valid, heartfelt questions:

How can a good God allow bad things to happen to those who love Him?
Why is God silent sometimes when we need Him most?
Why did God not answer any of Job's questions?

We need to move to the end of Job's story and listen to the last thing he says: "I had only heard about you before, but now I have seen you with my own eyes. I take back everything I said, and I sit in dust and ashes to show my repentance" (Job 42:5–6).

What happened? What happened to make Job retract everything he had said, take back every question he had asked? From chapter 3 through chapter 37, we see a different side of Job, not the worshiper but the questioner. He questions why he was born. He struggles with his innocence before God. He is furious with his friends. He demands that God step out of the silence and answer him. God doesn't answer one single question. He does so much more.

He pulls back the curtain that separates our limited humanity and His divine power and glory and gives Job a glimpse of who He is. It is a journey that leaves Job speechless. Although God never answers his questions, He makes it clear to the friends who had criticized Job for asking such bold questions that Job spoke the truth.

My servant Job will pray for you, and I will accept his prayer on your behalf. I will not treat you as you deserve, for you have not spoken accurately about me, as my servant Job has. (Job 42:8)

Job's story has a happy ending. His wealth is double what he had before, his wife gives birth to seven more sons and three more daughters, and he lives for an additional 140 years. Not every hard

God always
writes the last
chapter.

story has that kind of ending, but I don't think that's the point of the story. I find what Warren Wiersbe writes very helpful.

> We must not misinterpret this final chapter and conclude that every trial will end with all problems solved, all hard feelings forgiven and everybody living "Happily ever after." It just doesn't always happen that way! This chapter assures us that, no matter what happened to us, *God always writes the last chapter.*[5]

Never be afraid to bring your questions to God. Like my mother-in-law, Eleanor, rail against the silence. Just know that you are being heard and you are being held. We need to hold on to the glorious truth that is greater than our pain: Christ, the perfect Lamb of God, the One who spoke the world into being, is with us right now. Even when we can't see His plan, He is working. Even when we can't feel His presence, He is working.

Alexander Solzhenitsyn was a political prisoner in Russia for years. He was forced to work twelve-hour days with little food. One day he was too exhausted to carry on, so he fell to his knees, knowing that he would be beaten when the soldiers saw him. A fellow prisoner, also a believer in Christ, took his cane and with the point drew a cross in the sand. As Solzhenitsyn reflected on the sacrifice of Jesus, he rose to his feet and carried on.[6]

My dear friend, you are not alone. God is with you even in the silence. Heaven is watching over you, cheering you on. With the cross of Christ before us, we will hold on and not let go. We will hold on to Jesus.

HOLDING ON
TO HOPE

1. Even in the silence, you are being held.

2. Heaven is watching. Worship even in the midst of what you don't understand.

3. Even when we can't see God's plan, He is working. Even when we can't feel His presence, He is working.

Father God,
Thank You that even in the
silence You are with me.
Amen.

4

Holding On When
You're Afraid

Don't be afraid, for I am with you.
Don't be discouraged, for I am your God.
I will strengthen you and help you.
I will hold you up with my victorious right hand.

Isaiah 41:10

Out of difficulties grow miracles.

Jean de la Bruyere

PEOPLE OFTEN ASK ME how I ended up in America, singing, writing books, speaking, and hosting television programs. On reflection, I never meant to do any of those things; they just sort of . . . happened. Doors opened and I fell in. I went to seminary in London at eighteen to train to be a missionary in India because I couldn't think of anything that would terrify me more. I couldn't travel for more than a few miles in a car back then without throwing up (something that began after my father's death), and as women in India are often treated poorly (in fact, India has been determined to be the worst country in the world for women[1]), it seemed like the

perfect gift to give to God. I had such a messed-up view of the love of God. In my young mind, I had determined that if your own father who had loved you once could suddenly seem to hate you, then so could God. I believed that if I did something that I was afraid of, then He would be happy with me. When I graduated, though, instead of heading to Calcutta, God redirected my steps to work with Youth for Christ in Europe as a singer in a band. I was very comfortable being a backup singer, but then my boss suggested that I should record a single and premiere it at an upcoming festival. I will never forget that concert, as I had to have a bucket tucked behind the piano to throw up in between songs. I was terrified, but the record was very successful on British radio, and I was invited to host a gospel music show on BBC television. That led to the amazing privilege of singing at Billy Graham's crusades. Then the head of an American Christian record label signed me to a record deal and invited me to tour the States. Everything about that terrified me, and yet America fascinated me. To me, it was the land of cowboys and freedom, of a star-spangled flag and Disneyland.

So, after a couple of successful tours, I moved to America in my late twenties. Everything was so different, so much larger than life compared to my little Scottish town. The cars were bigger. The freeways were bigger. The hair was bigger. The food was bigger. And yet the drinks, strangely enough, were smaller. I became aware of this when I landed in Los Angeles and ordered a soda at a fast-food restaurant in the airport. When I saw how much ice was in my drink, I thought the girl was trying to pull one over on me and short me on my diet Coke.

"I may be Scottish," I said, "but I wasn't born yesterday. One ice cube is quite enough, thank you."

The girl looked at me as if I'd arrived not from Scotland but from another planet. She poured my drink out and gave me another with a solitary ice cube floating on top.

"Thank you and God bless America!" I said.

(Just FYI . . . should you ever decide to visit Scotland, you'll have to request more ice in your drink because one cube is all you'll get.)

Settling into my new life in California was exciting. I loved the weather and the beach and all the people walking their dogs. The number one thing that had been on my bucket list for years was having a dog. I had a dog when I was four years old. Her name was Heidi, and she was a sweet black and tan dachshund. But when my father had his first stroke, her tendency to tug at his bedroom slippers meant she had to go back to the farm where my parents had gotten her. I never quite got over that and had longed to have a dog of my own for years. But there was a problem. I had come to America as a contemporary Christian artist, and I was on the road a lot now. It wasn't fair to a dog for me to be gone so much. But then one phone call changed everything.

I Need Three Christian Dresses

I'd been in Canada singing at a Billy Graham crusade, and when I returned to my apartment, there was a message on my answering machine. (If you're under thirty, you might want to ask your parents what that is.) The message was an invitation to fly to Virginia Beach, Virginia, the following week to cohost a program called *The 700 Club* for three days. I had no idea what that program was, so I did a little research. Having watched a couple of episodes, I realized one thing was abundantly clear. I did not have the wardrobe for this. As a new-wave contemporary artist, my closet was full of jeans and leather pants, not Christian talk-show material at that time. So I went to the mall in search of a store that I'd avoided like the plague when I lived in Scotland. The store is called Laura Ashley. If you are unfamiliar with this label that is beloved by many, just think flowers, flowers, and more flowers. On the second floor of the mall, I found the store, windows ablaze in fabulous floral finery. I went straight up to the young woman at the cash register and shared my emergency situation.

"I need three Christian dresses and I need them quick."

She immediately seemed to know what I was talking about and produced three of their latest designs, which I purchased and took home. I didn't even try them on. I thought doing so might be too discouraging. I just knew I was going to look like a walking botanical garden.

On Sunday I flew into Virginia Beach and met with two of the *700 Club* producers that evening. They walked me through the layout of the following day's show, which I would be cohosting with Pat Robertson. My first day on air left a lot to be desired. I sat in the studio that morning, and the floor director began the countdown to going live . . . *five, four, three, two, one.* I have never prayed so fervently for the return of Christ as I did that day. I was clearly not up on current political events, and I used words that made no sense to an American audience. I told Pat that "I'd been able to get both my suitcases into the boot of the taxi even though it looked a wee bit small."

Yes, I know. It's a trunk and it's a "little bit" small. I know that now, but that morning I sounded as if I'd just escaped from the set of *Braveheart*. After the show, Pat and his wife took me out for lunch, and much to my surprise, he told me that he believed I was the right person for the job, and he offered me a permanent position as his cohost. That was exciting yet a little overwhelming. I would have to move almost three thousand miles across the country, and the thought of being on live television five days a week was terrifying. God had opened so many doors that I would never have knocked on and, even as I walked through each one, I was scared. I still felt like that five-year-old girl who was afraid of being known. What if someone saw the crack in my soul. But then Pat said something that brought my fear down a couple of notches: "You won't have to travel so much anymore."

Eureka! Straightaway I could hear the pitter-patter of four tiny paws.

I named him Charlie. He was a West Highland White Terrier. Westies are wonderful little dogs. Originally from Scotland, they are becoming an increasingly popular breed in the US. They are funny, loyal, and courageous. He was eight weeks old when I got him, and it was love at first sight. But when Charlie was only two years old, I almost lost him.

Grab Hold and Don't Let Go

We had been playing with a ball in our neighborhood park when I threw it too far and it rolled onto the road. Charlie ran after it at lightning speed. I called his name as loud as I could as I tore after him. I got to the road just in time to see his ball roll into a storm drain, and as Charlie looked in, he slipped and to my horror fell into the drain. I ran across the road and put my arm down into the drain to see if I could touch him. I couldn't. It was the kind of narrow yet deep drain that ran below the sidewalk with a heavy manhole cover on top. There was a hole in the cover, and so I lay on my stomach and looked to see if I could see him. He was perched on a narrow ledge about five feet below me, wet, dirty, and whimpering.

I broke my nails trying to lift the manhole cover, but it was too heavy. So I ran to a neighbor's home and asked the husband, who answered the door, if he could help me. He got a crowbar from his garage, and he and his teenage son followed me to where Charlie was stuck. When they got the manhole cover off, I could see my precious little dog shivering in the cold. I knew that if he slipped off that wet ledge, he would be lost forever.

The dad came up with a plan, and his son agreed. He said he would hold his son's legs and lower him down into the drain, as the boy was tall and skinny. I'll never forget that moment. "Okay," I said, tears flowing down my cheeks. "When you reach him, grab hold of him and don't let go. It doesn't matter where you grab him, just hold on. Even if he barks or wriggles or growls at you, just don't let go."

He nodded his head, then unexpectedly hugged me—a simple thing that touched me deeply.

He lay flat on the sidewalk, and then his dad lowered him into the drain, holding tightly to his ankles. I heard Charlie yelp when he reached him, and then the boy called to his dad to pull him up. When he appeared holding my scared little mucky pup, I threw my arms around both of them. I thanked the dad and his son from the bottom of my heart and made a mental note to get the boy a gift. In that moment, honestly, I would have given him a kidney.

I held Charlie all the way home, and when we got inside the front door, I lay on the floor and sobbed. Charlie licked me over and over, apparently none the worse for wear after his big adventure, although seriously in need of a bath. I was still shaking with fear.

Have you ever been in a place like that? A place where you're literally shaking with fear? Your heart is thumping in your chest, you can't think clearly, there's a ringing in your ears, and you can barely move. There are many situations that take us there.

When you are being wheeled into surgery with no guarantee of a positive outcome.

When you are signing divorce papers that you never wanted to sign.

When you are walking into a courtroom to hear the sentence passed on your son on drug charges.

When you are three months behind on your rent and you're afraid you'll be evicted.

When you can't sleep because you have no idea where your child is that night or was many, many, many nights before.

Or perhaps you're in a place like Charlie was where if someone doesn't grab hold of you now and not let go, you're not going to make it.

Fear is one of the most intensely felt emotions we experience as humans. It can cause us to run for our lives or paralyze us, freezing us in place. Fear is often caused by what we can't control. I think

we'd probably all agree at this point in our lives that we get it now: we're never really in control. But there are still times when that reality becomes crystal clear, and the situation we're facing is so unpredictable and so devastating that we are gripped by fear.

Shaking with Fear

I am very familiar with the psalms where David shares his confidence in the goodness and mercy of God, but my daily habit of reading three psalms every morning has caused me to dive deep into psalms I've rarely read. I have my go-to psalms; you probably do too. They are the ones that we know will bring us comfort or strength. But being disciplined in reading through all the psalms—yes, even that really long one—has allowed me to unpack some jewels I would have missed. I discovered a psalm where David is literally shaking with fear. It's Psalm 55. Let's look at what was happening in David's life when he wrote it.

> Open your ears, God, to my prayer;
> don't pretend you don't hear me knocking.
> Come close and whisper your answer.
> I really need you.
> I shudder at the mean voice,
> quail before the evil eye,
> As they pile on the guilt,
> stockpile angry slander.
> My insides are turned inside out;
> specters of death have me down.
> I shake with fear,
> I shudder from head to foot.
> "Who will give me wings," I ask—
> "wings like a dove?"
> Get me out of here on dove wings;
> I want some peace and quiet.

I want a walk in the country,
 I want a cabin in the woods.
I'm desperate for a change
 from rage and stormy weather. (vv. 1–8 Message)

"I shake with fear, I shudder from head to foot." Strong, desperate words from the king of Israel.

John Phillips, a preeminent scholar on the Psalms, says there is little doubt that this psalm was written during the time when David's son Absalom had rebelled against his father and was determined to claim Israel's throne.[2] David wasn't a young king here. He was in his sixties and had seen a lot of life, a lot of wins and a lot of losses. Absalom's support in Jerusalem was rising, and David was afraid of his own son. What a stab in the heart that had to be. I can't wrap my head around what it would feel like to know that a child you love, a child you picked up when they fell down, a child you read to and prayed with at night now wishes you were dead.

But there's more going on here for David. David knows that he has brought some of this trouble on his own head. There must have been moments in the quiet of the evening when he reflected on past mistakes and where those mistakes had taken him. David knew that God had forgiven him for his blatant sins, but I wonder if forgiving himself was a little more difficult. He'd had an affair with another man's wife, Bathsheba. Not just any man. Uriah was part of the Navy SEAL team of David's reign. He was brave and good and fiercely loyal to David. Yet David sent him back to the front line of a battle that was sure to cost him his life, and it did. That had to weigh heavily on his shoulders in quieter moments.

For most of his life, David was an excellent commander of the army, but he was not a good father. He had caused a great deal of division among his children, and now his beloved son Absalom was out to destroy him.

Past Mistakes and Wrong Choices

One of the greatest challenges to our faith, even among those of us, unlike David, who live beyond the death and resurrection of Christ, is that the waves of our past mistakes or wrong choices often wash up on the shore of our souls when things go wrong.

We wonder:

Did I cause this to happen?

What would have happened if I'd stayed in my marriage?

Would this have happened if I'd never had that abortion?

Am I being punished now because of that stupid affair?

Am I facing bankruptcy because I wasn't faithful in my giving?

Did I try to force my faith on my children, causing them to want nothing to do with it?

When we believe that our actions have caused devastation not only for us but also for those we love, we experience fear that is like an overwhelming sickening feeling in the pit of our stomachs.

I have spent time with so many women who live under the burden of regret. Even though they know in their heads that when Christ forgives us, He removes our sin as far as the east is from the west, that truth still feels a little too good to be true. We can know it in our heads, but we struggle with it in our souls. It's as if each one of us has a set of scales inside our mind. Somehow, the wrong we've done and the mistakes we've made seem to weigh more than the forgiveness of Jesus. We often feel that we're getting what we deserve.

Before we look at the relief that David found and the overwhelming grace that is right here for you and me, I want to acknowledge that of course there are consequences for poor choices and past mistakes. As I mentioned in chapter 2, Barry and I had to deal with financial pressures when we foolishly moved ahead and bought a

house before our other home had sold. We knew that God had forgiven us, but we still had to deal each day with the reality of having put ourselves in a dreadfully vulnerable financial position. It put a strain on our marriage, and I know our son felt that tension. How we longed to turn back the clock and undo the damage we'd done, but that wasn't possible. We had to walk out our trust in the goodness and grace of God every single day. Even when we were afraid, we had to hold on.

So, yes, there are consequences for our sin, our wrong choices, our mistakes, our foolishness, but we are not left in our fear and regret; we are never left alone.

Let me just say here and now, before we move on to one more paragraph or turn one more page, as believers in Christ, we do not get what we deserve. We get what we *don't* deserve. That's God's grace. Do you remember the last words that Christ spoke on the cross? Let me remind you.

> Jesus knew that his mission was now finished, and to fulfill Scripture he said, "I am thirsty." A jar of sour wine was sitting there, so they soaked a sponge in it, put it on a hyssop branch, and held it up to his lips. When Jesus had tasted it, he said, "It is finished!" Then he bowed his head and gave up his spirit. (John 19:28–30)

The Greek word used here for "finished" is *tetelestai*. This word has been found on ancient tax documents. Written across the papyrus, it literally means "Bill paid in full." Do you feel the weight of that truth? Whatever you have done, whatever regrets you might have, whatever wrong paths you may have taken, with those final words of Christ, He stamped over your life and mine "Bill paid in full." The great biblical orator and pastor Charles H. Spurgeon wrote,

> An ocean of meaning in a drop of language, a mere drop. It would need all the other words that ever were spoken, or ever can be spoken, to explain this one word. It is altogether immeasurable. It is high; I

As believers in Christ, we do not get what we deserve. We get what we *don't* deserve. That's God's grace.

cannot attain to it. It is deep; I cannot fathom it. IT IS FINISHED is the most charming note in all of Calvary's music. The fire has passed upon the Lamb. He has borne the whole of the wrath that was due to His people. This is the royal dish of the feast of love.[3]

Christ took on Himself what He did not deserve so that we don't have to bear what we do deserve. That is freedom. That is light being shone into the darkest corner of your soul. Take a moment here if you will and thank Jesus that although you will face many struggles in this life, you never have to fear because of who God is. When David remembered who God is, it changed everything.

Take Your Fear to Your Father

What can we learn from this greatest of all kings of Israel? He made many mistakes and yet we read, "But God removed Saul and replaced him with David, a man about whom God said, 'I have found David son of Jesse, a man after my own heart'" (Acts 13:22). That is a fascinating description of a man who messed up so badly. Clearly, what God saw in David was a fallible human being who loved Him passionately. That's what God looks for in you and me. Yes, we'll make mistakes, we'll fall down, but do we love Him? Jesus covered our sin. God wants our hearts.

John Phillips suggests that there appears to be a break in the writing of Psalm 55. In the first eight verses, David is crying out in pain and despair. His own son is trying to kill him, probably causing a more sickening fear than any he had faced in battle before. And David had faced many battles. In fact, that's why God didn't allow David to build the temple but passed the privilege on to his son Solomon. David had too much blood on his hands. This is how the section we looked at earlier ends before David remembers who God is:

> Get me out of here on dove wings;
> I want some peace and quiet.

I want a walk in the country,
 I want a cabin in the woods.
I'm desperate for a change
 from rage and stormy weather. (vv. 6–8 Message)

Haven't you ever wanted to do that—just get out of town, go somewhere quiet, like a cabin in the woods with no cell phone service? I know I have. Can you feel David's weariness, his desperation? He's at the end of himself. He's exhausted, heartsick, and broken. He had been quickly taken out of the city for his safety by his commander in chief, Joab. Everything else was left behind. What makes this devastating situation even more painful is that the person by Absalom's side is David's friend Ahithophel.

There is nothing worse when you're in a terrible situation, when you feel as if you're fighting for your life, than discovering that the person who has stabbed you in the back is one of your best friends. We read, "It is not my foes who so arrogantly insult me—I could have hidden from them. Instead, it is you—my equal, my companion and close friend. What good fellowship we once enjoyed as we walked together to the house of God" (Ps. 55:12–14). Not only was Ahithophel one of David's closest friends, but they had also worshiped together. That seems like the ultimate betrayal, and it broke David's heart. "David walked up the road to the Mount of Olives, weeping as he went" (2 Sam. 15:30).

His best friend and his favorite son are out to kill him. Unimaginable! So what turned things around for David? When he was holding on by a thread, overwhelmed by fear and grief, what changed things for him? It seems as if in the quiet of where he rested, David remembered God's promise and wrote the rest of Psalm 55. He knew that he had been anointed by God as king of Israel and that no matter how things looked, and they didn't look good, God is a God who always keeps His Word. The tone of the psalm changes. David moves from despair to hope. "But I will call on God, and the LORD will rescue me" (Ps. 55:16).

David stopped looking around and started looking up. I know that sounds simplistic and "the right thing to say," but it's a life-saving truth. Remembering who God is, remembering His promise changed everything for David. It will for you and me as well. It was as if David was precariously balanced on a ledge five feet below ground just like Charlie, and God reached down and grabbed hold of him. What David wrote still speaks to us today:

> Give your burdens to the LORD,
> and he will take care of you.
> He will not permit the godly to slip and fall. (Ps. 55:22)

David made this declaration *before the battle even began.* He knew things were bad, but he kept his eyes fixed on God.

I don't know what's going on in your life right now as you read this, but I want to remind you, my friend, that God keeps His promises. There are situations when we feel betrayed and wounded, and the great temptation is to try to fix things ourselves. We get to choose. We can trust our own ability to untangle a mess, to fight our own battles, or we can hide ourselves in the shadow of the Almighty. We can take our fear to our Father.

One of the greatest heartaches of my life happened when I was hospitalized with clinical depression. A friend I loved and trusted began to speak against me, saying that I was a liar. She said that my father didn't die by suicide and that I had made it up to get attention. I was already at the lowest point in my life, and when news of what was being said about me reached me in the hospital, I asked God to take my life. I was already terrified to be where I was and now it felt as if the walls were coming down on top of me. What if everyone believed this person? I had never felt more primally afraid in my life. I was so alone and so afraid. I felt too weak to even begin to try to defend myself. I was on that ledge, and I knew for sure I was going to slip and fall and there was no one to save me. (It would take

years for my friend to be willing to talk to me. When she did, she admitted that she was falling apart at that time too and felt that she couldn't get help. She was deeply disappointed in herself but found it more comfortable to lash out at me. I am profoundly grateful to our merciful God that we were finally able to sit down and weep together. We were both afraid, just in different ways. I know now, in retrospect, that we were both being held.)

One night when I couldn't sleep, I picked up my Bible, one of the few personal items I was able to keep in my hospital room, and I read this:

> Yet I am confident I will see the Lord's goodness
> while I am here in the land of the living.
> Wait patiently for the Lord.
> Be brave and courageous.
> Yes, wait patiently for the Lord. (Ps. 27:13–14)

That's what I did. I waited on God. Even on the nights when I was most afraid, I took my fear to my Father. I didn't try to put out all the little fires that were burning around me. I waited on God. Now let me say, there may be times when you have to speak up to right a wrong, but keep your eyes fixed on Jesus. Let your hope be in Him, not in your own ability to fix things or the response of others.

David lived to see God's deliverance. Absalom and Ahithophel lost their lives, and King David was restored to his rightful throne. David made it clear to all the people of Israel that God was the One who had saved him.

> He reached down from heaven and rescued me;
> he drew me out of deep waters.
> He rescued me from my powerful enemies,
> from those who hated me and were too strong for me.
> They attacked me at a moment when I was in distress,
> but the Lord supported me.

He led me to a place of safety;
 he rescued me because he delights in me.
 (2 Sam. 22:17–20)

Don't you love that? "He rescued me because he delights in me." David wasn't delivered because he did everything right in life. He was delivered in the midst of his fear because God loved him. Sometimes when things go wrong, it's tempting to think that God is angry with us or that He is punishing us. No! God loves us. He doesn't just love "the world"; He loves you and me. He loves you right now whether you are in the best days of your life or your life is falling apart. God is for you.

Not all rescues look the same though, do they? Sometimes we are delivered out of a situation, and sometimes we are delivered from fear *in* a situation. Sometimes God answers our prayers in the way we want, and at other times the gift is God's presence with us even when our circumstance doesn't change. I've experienced both of these in my life. There is one situation I will never forget.

Choosing to Take Refuge in God

When Christian was four years old, we thought we were going to lose him. At four, he was into everything, so when he began to slow down and nap more than normal, I was concerned about him. I took him to see his pediatrician, and after he examined him, he sent us home saying that he thought everything was fine and that it might just be a change in the weather or allergies. If you're a parent, you know this: we instinctively know when something is wrong with our child. So I took him back. This time the doctor ran blood tests. When he came back with the preliminary results, he seemed concerned. He told us that he'd have a better picture by the following day. He gave Christian a cartoon sticker, told us not to worry, and left the room.

Whether you are
in the best days
of your life or your
life is falling apart,
God is for you.

Barry took Christian to the car to get his juice box, but I went back inside and asked to see the doctor again. He was a friend, and I asked him to be straight with me and let me know what he thought could be wrong. He was reluctant, but I pressed him. He said it could be anything from one to ten, from something as simple as allergies to low iron count to something more serious. I asked him what the more serious thing was. He paused for a moment, then he sat down and said one word: "Leukemia."

We drove though McDonald's on the way home because Christian wanted a Happy Meal. At that moment, I would have bought him a pony. He asked if he could sleep in our bed that night, and by eight o'clock, he and Barry were fast asleep. I paced the floor all night trying to bargain with God.

"If it is leukemia, please, please give it to me. He's too little to bear this."

I was so afraid for my son. I wanted a normal life for him. I didn't want hospitals and chemotherapy and pain. About three o'clock in the morning, I read this: "God is our refuge and strength, always ready to help in times of trouble" (Ps. 46:1).

I grabbed hold of those words and reminded God of what He had said. I stood in the kitchen and prayed out loud:

Father,

I'm reminding You of Your promise. You have promised to be a refuge, so I am choosing now to take refuge in You. I'm afraid, and I need Your help. You've said that You are my strength, and I need Your strength right now, as I don't have any of my own. I'm in trouble. Please help me.

As I poured out my fear and pain, I felt God pour in His love and peace. Eventually, I fell asleep on the sofa in the den and slept until the doctor called the following morning. It was good news. Christian

was anemic, easily treated. I was so relieved, grateful that he would never even have to know of the possibility of something worse.

Not long after that, I was speaking at a conference and shared that story. At the end, a woman came up to me and told me that she got the other phone call, the one you don't want. She must have seen the look on my face as I thought of how my happy outcome must have been like salt in an open wound to her. She grabbed my hand and said, "No, Sheila, you don't understand. What I'm trying to tell you is this: Whether you get the answer you pray for or the answer you fear, God is with us. He is always with us."

I thought about that for a long time. We had both experienced the hand of God reaching down into the place where we had fallen. Our outcomes were different, but the one thing we shared was the gift of God's presence even in the midst of our fears. The gift of His peace.

I want to pause here and pray for you right now. I'm asking God to give you the strength to keep holding on when you're afraid. I'm asking God to hold you and not let go, even if you bark or wriggle or growl.

Life is full of unexpected miracles if we have eyes to see them. Sometimes the greatest miracle is the one that happens in us. We discover at a depth we've never known before that we are held, we are loved, we have no need to fear.

HOLDING ON
TO HOPE

1. Because of Jesus, we get what we don't deserve—and that's grace.

2. God always keeps His Word.

3. Whether you get the answer you pray for or the answer you fear, God is always with you.

Father God,
Thank You for Your presence.
Speak peace into my fear.
Amen.

5

Holding On When You've Messed Up

> Have mercy on me, O God,
> because of your unfailing love.
> Because of your great compassion,
> blot out the stain of my sins.
> Wash me clean from my guilt.
> Purify me from my sin.
> For I recognize my rebellion;
> it haunts me day and night.
>
> Psalm 51:1–3

> The gospel is this: We are more sinful and flawed in ourselves than we ever dared believe, yet at the very same time we are more loved and accepted in Jesus Christ than we ever dared hope.
>
> Timothy Keller

I'VE BEEN ON A DIET for over forty years. In my twenties and thirties I could skip lunch or dinner and lose a couple of pounds. Now I need to skip January. I never get very far overweight, but fifteen pounds on my little Scottish frame is a lot—enough to limit

what I can wear to what I refer to as "the fluffy section" of my closet. I decided one day that what was missing in my day-to-day routine was exercise. Now, I realize that many of you love to work out or to run, but I could never wrap my mind around running unless I was trying to catch a bus. Then I saw a commercial for an incline tread-mill. It came with the promise of unparalleled interactive training. Ta-da! I knew that this was just what I needed. I had messed up every time I joined a gym, but this was my big breakthrough. It was a bit expensive, but I assured Barry I would use it every day. I remember the very moment it arrived. Two burly guys carried it upstairs and set it in the perfect spot where I could watch TV as I embarked on this life-changing journey.

Day one went well, but the following morning I was a little sore—actually a lot sore—so I decided I should rest. I didn't want to overdo it. It could be dangerous to do too much too soon. Unfortunately, that little rest turned into five years. Barry made good use of it though. It became his closet, and he hung his clothes on it every night.

Then 2020 hit, and it became abundantly clear to me that if I didn't do something soon, I would need a whole fluffy closet. So I moved his clothes and his towel, dusted off the treadmill, and put on my old "running" shoes. I stepped on and hit the power button. Nothing. I hit it again. Nothing. I went downstairs and dug out the manual. I turned to the troubleshooting page and walked through every step. It was no help at all, but there was a telephone number to talk to a technical advisor for only $5.99.

I called the number and after fifty minutes on hold was connected to "Herbert." I explained my dilemma and how disappointing it was that after only one day, the machine was no longer working. (I left out the five years part.) Herbert asked me one simple, pro-found question. "Is the machine plugged in to the wall socket?" I thanked Herbert and hung up. I could feel Barry smirking behind me. I plugged it in and hit Start, and I was off like a winner at the Kentucky Derby. I now know that one should ease into this disci-

pline, and hitting the incline button to level 10 on your second try is . . . ambitious. I tried with everything in me to hold on until I could bring the machine back down to earth, but it tossed me off like a limp rag. I hit the bedroom wall and, despite the supposed protection of my running shoes, broke my little toe. Somehow I always mess up. I have these grand, lofty plans of how I'm going to "live my best life now," and more often than not, I hit the wall. Perhaps you've been there too?

It's one thing to mess up on a diet plan or skip the gym for a few weeks, but what do you do when it feels as if your whole life is a mess? I remember how that felt. I remember it so clearly.

When I Was Falling Apart

I don't usually reread my books once they're published unless it's to prepare a message for a speaking engagement. It had been years since I had written *Honestly*, the book in which I tell for the first time the story of my being hospitalized for clinical depression, but I decided to pull out a copy and read it one morning. It was an emotional experience revisiting the most vulnerable time in my life. When I wrote *Honestly*, the stories that poured out of me were not happy ones. In fact, I never intended to have it published. I wrote it as a journal for myself, a place to pour out the pain that was inside me and to record all that the Holy Spirit was teaching me. One of the side effects of severe clinical depression can be memory loss, and I didn't want to lose any of the puzzle pieces God was putting back in place. It was only when I began to understand that other people who loved Jesus also struggled with mental illness that I decided to publish my journal.

Sitting outside on a warm spring morning and reading my book again helped me see not only how far Christ had brought me in my journey but, honestly, how much further I have to go. As I paused on the short poems I'd written, they told a vivid story of the storm

that had been raging inside me back then. I remembered the fear I felt: deep gut-level fear of what would happen to me when people found out that I had spent time in a psychiatric hospital diagnosed with a mental illness. I wrote,

> It's all over, the curtain's coming down
> The crowd is going home, the lights are going out.[1]

As I read those words again, I felt a fresh wave of emotion wash over me. It was the kind of wave with painful history attached. Do you know what I mean? Not all waves of emotion are like that. For example, I can see a mom pushing her little boy in a stroller and a wave of emotion washes over me, but it's a happy wave, a wave with sweet memories attached from when Christian was a little boy. Or I'm watching a movie that's set in Scotland and I recognize the place as somewhere I loved as a child. Those waves are welcome. They touch on memories we treasure.

But as I'm sure you know, there are other types of waves that wash up painful memories. Those memories have history attached that we'd rather not revisit. Reading a couple of lines from that short poem again did that for me.

I remember feeling discarded, lost, messed up. On the day that I left the Christian Broadcasting Network to drive to the hospital in Washington, a senior staff member told me that I was going to damage the ministry when people found out that I'd been in a psychiatric hospital. He told me that the devil was going to use me because I was a weak link in the ministry chain. Then he said this: "You will never be special again." That's how I felt: weak, a failure, a mess that should be thrown away. (Pat Robertson never treated me that way. He was always kind, like a father.)

Mental illness, particularly in the church, held so much stigma back then. We have come a long way since, but when I was hospitalized, I didn't know of one other Christian who struggled with

depression. As far as I knew, I was the only one who was making a mess of her life, the only one who was failing God and falling apart. For me, it was the perfect storm—my greatest fear crashing into my most deeply held belief.

Don't let anyone see the real you or they will leave.

I'm too broken to be loved.

I wonder what those deeply held beliefs are for you? We all have them. They were usually etched into our souls when we were young. They're not all negative beliefs; many of the beliefs are the strong foundation stones that set us up for healthy choices later in life.

When you look for a husband, for example, if you were raised by a dad who loved you well and spoke words of life over you, you're less likely to fall for someone who tears you down. Such messages would sharply contradict what you know to be true about yourself and how relationships should be. Sometimes you might be blinded by love, but you have a much better chance of choosing someone who is healthy and supportive emotionally if you had a loving dad rather than a father who belittled you.

If you were raised to believe that you are smart and gifted and that God has an amazing plan for your life, then you won't quit the first time someone says no to you. When you want to join a team or go to a particular college or get a job, if the initial responses are negative, you'll try until you succeed.

Those kinds of deeply held beliefs are like a balloon that lifts us up. When the messages are negative, however, they are like weights that pull us right back down to earth the moment we try to rise. These are some of the lies we often believe.

You'll never amount to anything.

You'll always be overweight.

You don't deserve to be happy.

You were a mistake.

There's something wrong with you.

You look awful in that.

God will never forgive you for the mess you've made.

You'll never be special again.

Those kinds of messages have loud voices; they're hard to ignore. So how do we counter something we've believed for a long time? How do we hold on when we feel we've messed up? How do we silence the lies that have just enough truth in them to make us believe?

Silencing the Lies

Tearing down those lies is a process, I know. But I want to give you some tools that I use every day to counter the enemy's tactics.

Studying God's Word

I never let a single day go by without reading God's truth. I read it out loud. I choose a verse and meditate on it during the day. I read what God says is true about my life no matter how I might feel at that moment. If your deeply held beliefs tell you that you're not worth loving, that you'll never change, that you'll never recover from the mess you've made, then find some go-to verses that confront those lies. Here are a couple of my favorites.

> For the mountains may move
> and the hills disappear,
> but even then my faithful love for you will remain. (Isa. 54:10)

Observe how Christ loved us. His love was not cautious but extravagant. He didn't love in order to get something from us but to give everything of himself to us. (Eph. 5:2 Message)

And I am convinced that nothing can ever separate us from God's love. Neither death nor life, neither angels nor demons, neither our fears for today nor our worries about tomorrow—not even the powers of hell can separate us from God's love. No power in the sky above or in the earth below—indeed, nothing in all creation will ever be able to separate us from the love of God that is revealed in Christ Jesus our Lord. (Rom. 8:38–39)

Whatever your particular struggle is, find truth in God's Word and read it over yourself every day—out loud when you can—as often as you need to in order to silence the lies.

Prayer

In 2019, I wrote an entire book about prayer called *Praying Women*, as I recognized this was a weak area in my life. I needed a strategy to move forward. Now, I pray when I first get up in the morning. It's more of a "Good morning, Lord" than anything else. It's my way of greeting a new day in God's presence. Then I have times when I'm specifically praying and interceding for a particular person or situation. But I also talk to my Father all day long. When I'm in the car, waiting in the grocery line, when I'm happy, when I'm sad, when the treadmill throws me against the wall and I've messed up again, I talk to the Lord.

> Because he bends down to listen,
> I will pray as long as I have breath! (Ps. 116:2)

Know that God is always listening and that you can bring everything to Him.

Worship

I have a worship playlist on my phone. I've chosen songs that have deep spiritual truth, songs that remind me of the unfailing love of

Know that God is always listening and that you can bring everything to Him.

God. I worship along with them when I'm having a good day or a bad day. When I feel myself sinking and life feels messy, I listen and allow the words to wash over me.

> O LORD, I will honor and praise your name,
> for you are my God.
> You do such wonderful things!
> You planned them long ago,
> and now you have accomplished them. (Isa. 25:1)

Worship helps us take our minds off ourselves and focus instead on the God of love, faithfulness, and forgiveness. He is the God of the messer-upper.

Thanksgiving

There is great power in gratitude, in giving thanks for God's faithfulness and love. When life is hard, though, it's challenging to be thankful. That's why I think of thanksgiving as a choice, a discipline. Every day I thank God for five things. Some days those things are significant answers to prayer. Other days they are something as simple as our older dog, Tink, sleeping through the night instead of needing to go out five times. The simple act of thanksgiving reminds us that God is with us and that He is in control. One of the lessons that my dear friend Ruth Graham taught me is found in Paul's letter to the church in Philippi.

> Don't worry about anything; instead, pray about everything. Tell God what you need, and *thank him for all he has done*. Then you will experience God's peace, which exceeds anything we can understand. His peace will guard your hearts and minds as you live in Christ Jesus. (Phil. 4:6–7, emphasis added)

Paul makes a clear connection between giving thanks and experiencing peace.

These four disciplines were my go-tos, but over the last year I discovered a whole new discipline I hadn't considered in dealing with the impact of negatively held beliefs. It was hard for me to own at first. I had to call my broken belief system what it was. Sin. I had to embrace a whole new way of living that was not a once-for-all decision but a daily commitment to repentance. It has been life-changing.

Telling the Truth

During the self-isolation of the pandemic, everything we were familiar with changed. Families who were used to getting their children ready for school and then heading off to work now found themselves all at home, all the time. They were expected to do jobs they weren't trained for—teacher, plumber, electrician, lawyer, or entertainer of the year. I'm pretty sure the sales of headache medication went through the roof. People who lived alone were suddenly cut off from any social interaction. No small groups or gym trips or lunch dates with friends. It was as if someone took our puzzle, every piece in place, and upended the whole thing. We didn't even know where the corner pieces were anymore.

It was during this time that the ugly self-protective side of brokenness showed up in me again. I honestly thought I had put that to death over the years, but it had only been asleep.

Barry and I were talking with Christian one evening on another of our famous family FaceTime calls. Christian was saying how grateful he was to be able to see his friends' faces on Zoom video calls. It made him feel less alone. I had been worried about him, and I was very grateful that he could still have some interaction with his friends.

Barry is a noticer. He notices things that he thinks could be better, and halfway through the call, he noticed something about Christian's appearance. He suggested to him that he shouldn't wear his ball cap on video calls. He told him that he would look better without it.

That's all he said, but it triggered something in me and I totally over-reacted. It went a little like this. (Permission granted by all involved.)

"You shouldn't wear your ball cap on calls, Christian. You look much more handsome without it."

"It's just my friends, Dad. They don't care."

"Still, if you're going to be a clinical psychologist, you should get used to presenting a professional front." (Barry is brimming with suggestions.)

"I don't want to be that kind of counselor, Dad. I want to be real, be myself, be approachable."

"I still think you look better without it."

Enter me . . .

"Why do you always have to make such shallow comments, Barry? You make me so angry. He looks great the way he is . . . better than you do sitting here in the same torn sweatpants you've been wearing for months!"

As you can probably imagine, the call went quiet after that. Barry shut down; Christian shut down. A tsunami of guilt washed over me as I thought back to a counseling session the three of us had been a part of just a few years before. The genesis of that session was that I felt Barry was too critical of Christian at times. I had hoped the counselor would help Barry see the impact of his criticism, but by the end of the session, I realized that the real problem was me. I was the one who was messing up. I had asked Christian how I might be contributing to any tension in the home. I had expected him to say that it wasn't me, that it was his dad. That is not what he said. He said this: "Mom, I don't want to hurt your feelings." I told him he had complete permission to hurt my feelings. "Mom, when you get in the middle, it makes things worse. Dad and I love each other. Yes, he's hard on me at times, but we can sort it out, the two of us."

I was a little taken aback at first but honestly proud of his ability to articulate what wasn't working for him. It made total sense to me. I left that session determined to change. I could see that all I was

doing was turning the heat up on a situation they could work through together. My emotional responses were far more difficult for them to handle than the differences they were experiencing as father and son.

Now, here we were again. I didn't know what to say. No, I did. I should have asked for forgiveness straightaway. I didn't. Christian laughed it off, saying he had a paper to write, and signed off. Barry asked if I wanted to talk. I shook my head, so he headed upstairs to bed.

I sat on the sofa in our den feeling about five years old, alone and trapped. When I resist immediate repentance, I quickly fall into dark places. Old destructive thoughts come back to torment me; despair and feelings of hopelessness rise up like floodwater in the basement. Familiar lies had found their voice once more.

You've made a mess again.

You'll never change.

You're too broken to be a good mother.

Life is too hard.

You can't do this.

But this is what I want you to hear. One of the most powerful lessons I have learned over the years is this: there is power in the name of the Lord. No matter what you are facing, no matter what you have done, no matter how hard life is or how dark it feels, there is power in the name of Jesus.

As the tears began to pour down my cheeks, I didn't wait a minute more. When I've messed up, there is only One I can hold on to. I called out His name: Jesus!

I called out His name over and over.

Jesus! Jesus! Jesus!

I got down on my knees in the den and asked for forgiveness. I raised my arms to heaven and felt the sweet presence of the Holy Spirit filling me with peace. Simply put, I repented.

Repentance is an old-fashioned-sounding word, but it has a very simple, powerful, life-changing meaning.

In the Old Testament, two Hebrew words are used to help us understand repentance. The first is the word *nacham*. This means "to turn around or to change your mind." The second is the word *sub*. It is used hundreds of times in the Old Testament and is translated using words like *turn, restore,* and *return.* When we come to the New Testament, the Greek word that is translated "repent" is *metanoia,* which literally means "to change your mind."

Notice this: there is nothing here about being sorry. Repentance is not an emotion; it's an action. We can say we're sorry a million times, but if we don't turn around, if we don't change our minds, then nothing changes.

Somehow Barry's comment to our son triggered a wound in me. It felt like the rejection I had felt through most of my middle and high school life.

Not pretty enough.

Not thin enough.

Not enough.

My outburst was an out-of-proportion response with history attached.

I went upstairs and asked Barry to forgive me, which he immediately did.

I have to tell you, I never feel more human and whole than when I ask for forgiveness.

The problem I was dealing with was sin. We don't like that word in our culture. *Sin* sounds judgmental, but it is the reason Jesus came to this earth. He came to pay the price for our sin. If you grew up in a church community, you will have your own understanding of what sin looks like to you. We often tend to think of it, depending on our church traditions and culture, as the *big things* people do, such as adultery, murder, child molestation, and so forth. In other words, *it's the things other people do* that we wouldn't dream of doing. If you

grew up with no religious background, the word *sin* doesn't really come into the picture. There are good people and bad people. It's as simple as that. Yet the stark, unswerving message of the Word of God is that we are all sinners, every single one of us. The good news is that when we willingly embrace that truth, we have hope, because we hold on to Christ who came for sinners.

Filling the Void

Some of the questions I had in my mind as I sat down to write this book were these: Why are so many of us who love Jesus so unhappy? Why are we just hanging on by a thread? Why do we struggle in our relationships? Why is everything a little disappointing? Why is nothing quite as great as we thought it would be? Why do we keep messing up over and over again?

I wonder if it's because we have not allowed salvation to do its full work. Let me explain what I mean. When we embrace a life of faith, we know that our sins are forgiven. We are no longer sinners; we are sinners saved by grace. While that is gloriously true, I think we forget the full reach of what sin really is.

In his masterful work *The Reason for God*, Timothy Keller quotes French author and activist Simone Weil: "All sins are attempts to fill voids. Because we cannot stand the God-shaped hole inside of us, we try stuffing it full of all sorts of things but only God may fill it."[2] She wrote this after her dramatic conversion to Christianity. I've known this quotation for years, but I hear it differently now than I used to. I used to understand it as applying to those who have not yet come into a relationship with God. In other words, if you don't know God, you'll make money your god, or love or football or alcohol or your appearance or anything else you can name. But when I examine my own life, I see clearly that even though I gave my life to God when I was eleven, I've resisted letting Him fill all the void, the broken places, the fear-filled places, the tear-stained places, the messed-up

places. This was not an intentional resistance, just a broken understanding of how great and wholly invasive God wants to be in our lives. He wants to be our everything.

This is how Danish philosopher Søren Kierkegaard defined sin: "Sin is: in despair not wanting to be oneself before God. Faith is: that the self in being itself and wanting to be itself is grounded transparently in God."[3] Okay, I had to read that over a few times as well before I got it. I believe what he is saying is that being a Christian is more than just "giving our lives to Jesus" and knowing that now we're saved. It's much more than that. It's being our whole self in God's presence. It's being transparent, not all bad or all good but human and real and messy. It's taking off the mask and turning our real faces toward Him. It's loving Him above everything and everyone else. It's finding our *very* identity in Him. It's finding our *only* identity in Him.

We were created to worship, and we will worship something. If our worship of God is boxed into a Sunday or a Wednesday evening or whatever night we gather with fellow believers, what are we worshiping the rest of the week? Whatever we worship we will make an idol of. It can be your marriage, your job, your children, your career, your looks—just fill in the blank. The trouble with all of those is that they are essentially flawed in one way or another. When the things we worship disappoint us, we become angry and bitter. We build walls and listen to familiar lies. I've written at other times about coming to God as we are rather than as we wish we were, but I feel there is a greater depth to explore. I believe there is a greater freedom to be found.

Being Ourselves

I love what Psalm 51:1, which we read at the beginning of this chapter, says:

> Have mercy on me, O God,
> because of your unfailing love.

> Because of your great compassion,
> blot out the stain of my sins.

If you're familiar with this psalm, you know that David wrote it after Nathan the prophet confronted him about his affair with Bathsheba. How might Kierkegaard's definition of sin shed light on the actions David took?

At this point, King David was in his late fifties and should have been with his warriors in battle, but he wasn't. Second Samuel 11:1 tells us that it was springtime, when kings normally go to war, but David stayed behind in Jerusalem. All his warriors were where they should have been, but not David. We don't know who wrote 1 and 2 Samuel (Samuel's death is mentioned in 1 Samuel 25, so it clearly wasn't him), but the fact that the writer made the point that this was a time when kings normally went to war and that David didn't lets us know that something was wrong and others knew it. Perhaps David was bored or depressed, but he wasn't behaving as a king should. He saw Bathsheba bathing late in the afternoon when he got out of bed. When David asked his servants who she was, one of them identified her not only as the daughter of Eliam, which would be the normal way to identify a woman in those days, but also as Uriah's wife (2 Sam. 11:3). David was in a dangerous place and mindset, and he was being warned. Those moments are balancing-on-the-fence moments. We know that the next step we take has huge significance. You may have been there.

After a few dates, your boyfriend invites you on a weekend trip. You discover that he's booked only one room. Do you go?

Your spouse asks about a charge on your credit card. Will you own up to the truth that you bought something that was way outside your family's budget or pretend you know nothing about it to buy yourself some time?

A friend confides in you. It's a deeply personal secret. You're then with another friend who wants to know what's going on. Will you break your friend's trust?

Not all moments have the significance that King David's did, but every choice we make to sin or not to sin either opens the door for more of the light of Christ to shine in or gives entry to darkness.

David ignored his servant's warning and fell off the fence onto the wrong side of his calling. He sent for Bathsheba and slept with her. From that point onward, David had charted his course to disaster.

So let me ask you, What could he have done? If one aspect of sin is not wanting to be oneself before God, then that's one thing that tripped David up. If he was tired or discouraged or bored and had shown up just like that before God, he would have saved himself and many others a lot of devastating pain and heartache. If he had humbled himself before God, confessing what was going on inside him, telling the whole truth, he would have been embraced, loved, and strengthened by God.

It was a full year before he was confronted by Nathan. Guilt is a crushing burden to bear. David tells us that.

> When I refused to confess my sin,
> my body wasted away,
> and I groaned all day long.
> Day and night your hand of discipline was heavy on me.
> My strength evaporated like water in the summer heat.
> (Ps. 32:3–4)

That's a powerful picture. "I groaned all day long."

So what could I have done that night when Barry's comments triggered such a sinful response in me? I could have told them the truth. I could have said, "Wow, I'm not sure what's going on with me, but those comments made me feel bad inside. I think I need a few moments alone." I could have locked myself in the bathroom in God's presence and let Him love me. As Timothy Keller's quotation at the opening of this chapter says so eloquently, "The gospel is this: We are more sinful and flawed in ourselves than we ever dared

believe, yet at the very same time we are more loved and accepted in Jesus Christ than we ever dared hope."[4]

It's the worst news and the best news in the same sentence, and the order matters. If we focus on only the love and acceptance of Jesus, we see no need to own our flaws. Sin is not just about doing bad things; it's about putting anything else in the place that only God can fill. God doesn't want our stuff. He wants our whole self, our 100 percent this-is-who-I-am self. Good, bad, messy, and ugly. That is a struggle we all face. C. S. Lewis describes it this way: "The terrible thing, the almost impossible thing, is to hand over your whole self—all your wishes and precautions—to Christ. But it is far easier than what we are all trying to do instead. For what we are trying to do is to remain what we call 'ourselves,' to keep personal happiness as our great aim in life, and yet at the same time be 'good.'"[5]

The truth is that we've all messed up. Some of us just do a better job of concealing it than others. But we don't have to hide anymore. I believe God is offering us a whole new way to live, a way to live in radical freedom and grace. What might that look like? Let me give you a little picture. I have a friend whose son used to love to run outside naked when he was about four years old. I remember asking him one day why he liked to do that and he said, "It just feels good to have the sun all over me."

Now I'm not suggesting for a moment that we should adopt this darling boy's interesting habit. What I am saying is that don't you think it would be wonderful to be spiritually naked before God—no secrets, no closed doors, no hiding at all? When we mess up in big or little ways to live in the grace of quick repentance? Can you imagine how good it would be to feel the love of God all over you? It would be a whole new way to live and love.

Do you think this is an easier way to live or a more difficult way? I think it's both. I think it is easier simply because we can be real, transparent, and free. I think it is harder because God's not interested in a partial buyout. He's not into negotiations. He wants all of us.

God wants
our whole self,
our 100 percent
this-is-who-I-am
self. Good, bad,
messy, and ugly.

As Lewis writes, "Christ says, 'Give me ALL. I don't want just this much of your time and this much of your money and this much of your work. . . . I want you.'"[6]

So often we feel that when we've messed up in a particular area, we should surrender that area to God, but I say no! God wants all of us, our strengths and weaknesses, the things that make us laugh out loud and the things that make us cry. It's often at our most broken that we realize how loved we really are.

God's Bummer Lambs

I grew up in Scotland with sheep all around me, field after field of white wool and incessant bleating echoing throughout the green pastures. Of all the lessons I have learned from these defenseless, gentle animals, the most profound is also the most painful. Every now and then, a ewe will give birth to a lamb and immediately reject it. These rejected lambs are called "bummer lambs." Unless the shepherd intervenes and takes the lamb into his home, that lamb will die, not of hunger but of a broken spirit. So the shepherd will hand-feed it from a bottle and keep it warm by the fire. He will wrap it up with soft blankets and hold it to his chest so the lamb can hear a heartbeat. When the lamb is strong enough, the shepherd will place it back in the field with the rest of the flock. In the morning, the shepherd will stand at the edge of the field and call out, "Sheep, sheep, sheep!" The first to run to him are the bummer lambs because they know his voice. It's not that they are more loved; it's just that they believe they are loved.

> He calls his own sheep by name and leads them out. After he has gathered his own flock, he walks ahead of them, and they follow him because they know his voice. (John 10:3–4)

I will be a bummer lamb for the rest of my life, but that's not bad news; it's the best news. It's not that God loves His messy bummer

lambs more than the rest of His flock; it's just that we actually dare to believe He loves us even when we fall off the treadmill, hit the wall, and want to give up. King David was a bummer lamb. Every man, woman, and child who realizes that they have messed up and goes to the Shepherd just the way they are in transparent repentance will be held, will be loved back to life. We've heard His voice, we've been held close to His heart, and we are sold out to Him for life, missing pieces and all.

HOLDING ON
TO HOPE

1 • We've all messed up; that's why Jesus came.

2 • To repent means to change your mind, to turn around.

3 • There is life-changing power in the name of the Lord.

Father God,
I know I have messed up. Thank You
that You love me and that by Your grace
I have the freedom to change.
Amen.

6

Held by the Promises of God

So let us come boldly to the throne of our gracious God. There we will receive his mercy, and we will find grace to help us when we need it most.

Hebrews 4:16

In the same way the sun never grows weary of shining, nor a stream of flowing, it is God's nature to keep His promises. Therefore, go immediately to His throne and say, "Do as You promised."

Charles H. Spurgeon

I GREW UP WRESTLING with two sides of me. Both were me, but they didn't live well together. For years, they fought for center stage. The first one was, I believe, the real me. She was an adventurer, fearless, a glass-more-than-half-full kind of girl. She climbed trees, hugged random dogs, and as a child she introduced herself to anyone she met by her full title: "Hello, my name is Sheila Davina Walsh." She believed that anything was possible and that the world was beautiful and meant to be explored.

The second one appeared after my father's death and knocked that joy-filled, fearless child out cold. She was afraid of everything. She

was afraid of men. She was afraid of any kind of confrontation. Even in the mildest family argument, she saw the potential for disaster. She saw wolves in hedges that turned out to be dogs, but they still made her heart pound out of her chest. She was terrified of anyone in a mask because of what the mask might be concealing. She lived with a quiet dread that something was about to go terribly wrong at any moment. She believed all that based not on an irrational fear but on what she had lived through.

My father's intermittent rage before he died didn't just upend my family's puzzle; it scattered the pieces so far apart that it took years to find some of them again. As a child, I found it impossible to process what had happened in any way that made sense to me. When the one person you look up to and lean on more than anyone else becomes a terrifying stranger, where do you turn? I was very close to my mum, but my dad was my hero. He was the "Yes, you can!" voice in my life. The night before my father's brain aneurysm, all I wanted was a dog. In the weeks and months that followed, all I wanted was a place to hide.

The entire landscape of my life changed. I dreaded the phone ringing, not typical for a teenage girl. This was long before the arrival of cell phones. I remember we had an olive-green rotary phone connected to a landline in the hallway that sat on top of my mum's little bureau. I can still see her sitting there on a stool chatting away to her friends or family. To mum, the phone was a source of joy, of connection, but not to me. I knew that it was going to bring bad news, so I never answered it. If my mum or sister answered and told me the call was for me, I felt a sickening wave of panic grip my chest. My immediate thought was, *What did I do wrong?* even though I knew I hadn't done anything wrong. Nothing seemed sure in life anymore; everything and everyone could change in a moment. Promises were wafer thin. That kind of behavior is not rational, but it was real to me.

A Scattered Puzzle

In recent years, we've learned so much about how to help children process grief, trauma, and pain, but when I was little, we had no tools. The toolbox was empty. We simply didn't talk about it. It can be a devastating thing when children are left to draw their own conclusions about what happened to them. Inevitably, they bear the brunt of the blame on their own tender shoulders. Years later, when I spent that month in a psychiatric hospital, I met a woman who had chosen a life of service to God with a mission organization. She absolutely hated it and eventually had a complete breakdown and was sent home. Choosing that path was her way of trying to balance the scales in her life. She had endured childhood sexual abuse for years, which she decided was all her fault.

I pause here and think about you. I wonder if you can relate to that kind of internal battle. Traumatic experiences in childhood shift how we see and react to the world around us. The legacy can last for years.

If someone abused you in any way as a child, particularly someone you trusted to love and protect you, their actions can cast a long shadow on future relationships. Later in life when someone promises to love and protect you, a part of you, conscious or not, may doubt that promise. When you hit the inevitable bumps in the road that any relationship faces, they may have more significance and history attached to them for you. They may mean more than what is actually happening in that moment. I have spoken to multitudes of women and men who experienced abuse as children, and their stories break my heart. If this is your story, I am more sorry than I know how to put into words. I've heard the experience of childhood abuse described as being thrown into a dark, dirty ditch. What a wretched place for a child to land.

God's Word is not silent about the cries from that hellish place.

> The helpless put their trust in you.
> You defend the orphans. . . .

Lord, you know the hopes of the helpless.
Surely you will hear their cries and comfort them.
(Ps. 10:14, 17)

In my humanity, I want to ask God why He didn't simply intervene and stop my father's brain injury and subsequent abuse. I'm grateful that He hears the cries of those who suffer, but wouldn't a God of love want to prevent suffering? I don't have adequate answers for that. I don't know why God allows such evil to continue other than that we are still living in a broken world full of sin. I do know that from before the first human cry, there was a plan in place to save us. Knowing the loving heart of God, I can only imagine the pain our suffering causes Him.

I also know that we are called to live by faith and not by what we see or what makes sense to us. Being a disciple will cost us. I've never been more convinced of how we need to grasp hold of this truth. Being a disciple, a true follower of Jesus, will cost us. We're not joining a club when we become a Christian. We're joining a radical, die-to-yourself kingdom.

The "give your heart to Jesus and life will work out perfectly" message that we've often heard preached is not only damaging but also totally against what Scripture teaches.

I have told you all this so that you may have peace in me. Here on earth you will have many trials and sorrows. But take heart, because I have overcome the world. (John 16:33)

Jesus also tells us to take up our cross and follow Him.

Then Jesus went to work on his disciples. "Anyone who intends to come with me has to let me lead. You're not in the driver's seat; I am. Don't run from suffering; embrace it. Follow me and I'll show you how. Self-help is no help at all. Self-sacrifice is the way, my way, to finding yourself, your true self. What kind of deal is it to get everything

you want but lose yourself? What could you ever trade your soul for?" (Matt. 16:24–26 Message)

Following Christ is not a walk in the park, but we are never, ever alone, and He stepped into our suffering and put flesh and blood to the promises of God.

You Will Never Be Abandoned

Perhaps one of our greatest fears in life is that we will be left alone. When my son shared his nightmare with me about being afraid of being abandoned, it felt as if he was telling part of my early child-hood story. I want to pause here and help you see that no matter what might be going on, no matter what might be shaking the foundation of your life right now, because of what Jesus did, you will never be abandoned, never left alone.

God was willing, in Christ, to leave the glory of heaven and be-come a vulnerable child. He was willing to walk where we walk, weep where we weep, and on the cross receive the punishment for every one of our sins. We have a Savior who has suffered more than any one of us ever will.

I don't mean to minimize your suffering; let me explain what I mean by that. On the cross, when the sky turned midnight black, Christ was utterly alone. I can't begin to imagine what it was like for Christ, the perfect, sinless Lamb of God, to have His Father turn His face away from Him. Their eternal union was broken for three long, agonizing hours. We are simply allowed to listen to His cries. "At noon, darkness fell across the whole land until three o'clock. Then at three o'clock Jesus called out with a loud voice, '*Eloi, Eloi, lema sabachthani?*' which means 'My God, my God, why have you abandoned me?'" (Mark 15:33–34).

Let's stay there for a moment. It's easy to think we know the story and hurry over those devastating hours to get to the moment when

Christ victoriously rose from the dead. When we do that, we miss the invitation into all that Christ suffered for us. We miss the profound empathy our Savior has for the depth of our suffering, because He has been there.

None of the Gospel writers attempt to explain why the sky turned as dark as night from noon until three o'clock, but Jewish historian Josephus records that three o'clock in the afternoon (or the ninth hour in the Jewish clock) was when the evening sacrifice was made. The one true Passover Lamb was about to be sacrificed for us.

Christ had been on the cross since nine o'clock in the morning. Three hours of physical agony yet nothing compared to what the next three hours would hold. When the sky turned dark, for the first time in eternity, God turned His face away from His Son. Christ wasn't simply quoting from Psalm 22 when he cried out, "My God, my God, why have you abandoned me?" He was living it. During those three hours, Christ, who had never sinned, was treated as if He had committed every sin that those of us who would come to trust in Him had ever committed. Addiction, adultery, greed, abortion, self-righteousness, pride, hatred, bitterness, unforgiveness . . . the list is endless. Christ drained the cup of the wrath of God to the very last drop—too much for us to comprehend. To you who have suffered or are suffering right now, I say this: you did not deserve what happened to you; when tragedy strikes, it is not your fault. Christ did not deserve what happened to Him, but it was His choice because He loves you. It was His choice to fulfill every promise ever made to us from Genesis through Revelation.

If you have ever felt alone, abandoned, forgotten, I want you to know that Christ is right there with you. He knows what it feels like to be tossed into that dark, filthy ditch. Did you know that if Joseph of Arimathea hadn't gone to Pilate and asked for Christ's body, He would have been tossed onto the garbage heap outside the walls of Jerusalem and burned with the other criminals?

He was disregarded. You are seen.

His cries were ignored. You are heard.

He was abandoned. You are never alone.

That is a rock-solid promise!

For God has said,

> "I will never fail you.
> I will never abandon you." (Heb. 13:5)

In the original language, this text uses a double negative for emphasis. It's as if the writer to the Hebrews wanted to make sure his readers didn't miss the point. In his study Bible, my dear friend Dr. David Jeremiah writes that the verse can be translated this way: "I will never, by no means leave you, and I will never, by no means utterly forsake you."[1]

Never.

By no means.

Whatever your pain is, whatever happened to you that still torments you, I ask you now in the name of Jesus to reject the lie of the enemy that you were abandoned, all alone. You were never abandoned. And you were never alone. Your pain is real, but you are not alone. You were not then. You are not now. You will never be abandoned. You are held by that promise of God.

Christ Is Our Counselor

Pain often raises more questions than answers. A young woman at an event several years ago asked me a question. "If I tell you my story, will you believe me?" I assured her that I would, but her question stayed with me. What must it be like to go through a painful situation, a devastating trauma, a life-shaping event and not be believed? I can't count how many stories I've heard through the years of people who, when they found the courage to tell someone what

You will never be abandoned. You are held by that promise of God.

had happened to them, were not believed. That has to be like pouring salt into a still-open wound. I will keep the individuals anonymous, but several of these stories will never leave me. The "why" questions are haunting.

A twelve-year-old girl decides to tell her mother that the live-in boyfriend is sexually abusing her. Her mom punishes her, calling her a liar.

A young boy scrapes up the courage to tell his pastor that the youth minister is abusing him. He is not believed, and the abuse continues for three more years.

A teenage girl tells her parents that she needs help to deal with her crippling depression. They tell her there is no such thing for a believer in Christ. She should just pray and read her Bible more. She dies by suicide.

I could fill page after page with these stories, but you have your own. It is a double betrayal to suffer and then not be believed.

One of the hardest lessons I've had to teach my son is that life is not fair. Christian has a very compassionate heart, and with that empathy comes a passion for justice. It is one of his greatest strengths, but a strength like that can be an Achilles' heel if you don't know what to do with the inequity of life.

I remember picking him up from school one day, and I could tell by the look on his face that he was struggling with something. Eventually, he opened up and told me what had happened. It boiled down to one of his best friends doing something disruptive in class and blaming Christian for it. That was hard enough, but the final straw was that the teacher believed his friend. Christian asked his friend to tell the teacher the truth, and he refused. I remember the look in his eyes as he told me his story. He was hurt and angry. Why did the teacher believe his friend? Why wouldn't his friend tell the truth?

These moments in life matter. Will we be believed? Obviously, I believed him, but even if we are believed, what do we do with the raging sense of how unfair life can be?

That evening when Christian was ready to go to bed, I asked him to take a walk with me. Before we left, I gave him a very large, Costco-sized bag of flour to carry. I told him that we'd need it on our adventure. We walked for quite a while in silence; the only interruption was this frequent question known to parents far and near: "Are we there yet?"

Finally, he sat down on the grass and declared that he could go no farther. Then we talked. I told him that his friend was probably asleep by now, and here he was, carrying a heavy bag of flour instead of being tucked in bed. He reminded me that the flour and the walk were my idea. I smiled and told him I was aware of that but wanted him to understand what the flour represented.

"The flour is like the pain you're carrying inside. You want life to be fair, darling. I get that. The reality is that *fair* doesn't live here, but Jesus does."

We talked about the power of forgiveness, which he was initially very resistant to. His friend wasn't sorry, so why should he forgive him? Good question. As we sat at the edge of a golf course under a perfect full moon, I shared with him a principle about forgiveness that has been life-changing for me. "God doesn't want you to forgive so that you are a good Christian. No. Forgiveness is God's gift to us so we can live in a world that isn't fair."

When you have been wounded by someone who is not sorry, what do you do with that pain? Unchecked, it can fester for years and color the rest of your life. Sadly, I've prayed with many men and women who are seemingly frozen in what happened to them.

You were abandoned by your husband. He's moved on, remarried, and is financially secure. You have been left in a vulnerable place, alone, discarded. So unfair.

Someone lied about you at work. It cost you your job. Now not only are they secure, but they have also been promoted. So unfair.

You fought tirelessly to get full custody of your children because of the kind of person you were married to and how badly they treated

Forgiveness is
God's gift to us
so we can live
in a world that
isn't fair.

your children in the past. Your ex's lawyer says that you are mentally unstable and on psychiatric medication. The only reason you're taking the medication is to help you get through this nightmare. The judge sides with your ex and rules in their favor. So unfair.

The scenarios are endless, but the question is simple: What do you do in a place like that?

Are you stuck forever?

Are you stuck until someone says they're sorry?

Are you stuck until someone believes you?

No! Jesus offers a better way.

If you have carried an internal bag of flour around for years, there is a place to take it. If you have been wounded and then not believed, there is an invitation to a place of rest and peace. Forgiving someone doesn't make what they did right. It doesn't lessen the wrong; it sets you free. It's as if you take this gigantic bag of flour that you have carried for so long to the foot of the cross, where the greatest injustice in human history occurred, and you leave it there. You give it to Jesus. You let Him deal with it all because He loves you and—I want you to hear this—*He believes you.* That's a promise. The world we live in is not fair. We all know that. What Christ offers to each one of us is a place to take that baggage. Eugene Peterson paraphrases Matthew 11:28–30 this way in The Message:

> Are you tired? Worn out? Burned out on religion? Come to me. Get away with me and you'll recover your life. I'll show you how to take a real rest. Walk with me and work with me—watch how I do it. Learn the unforced rhythms of grace. I won't lay anything heavy or ill-fitting on you. Keep company with me and you'll learn to live freely and lightly.

Don't you think it's amazing that hundreds of years before Christ was born, we were told through the prophet Isaiah that a Counselor called Wonderful was on His way?

For unto us a Child is born,
Unto us a Son is given;
And the government will be upon His shoulder.
And His name will be called
Wonderful, Counselor, Mighty God,
Everlasting Father, Prince of Peace. (Isa. 9:6 NKJV)

You will often hear the phrase "Wonderful Counselor" put together when this passage is read, as if the first word is describing the kind of counselor Jesus will be. But in the original language, "Wonderful" stands alone. It is not an adjective; it's a noun; it's His name. When the angel of the Lord (an Old Testament appearance of Christ) appeared to Samson's father in the book of Judges, he said this: "Why do you ask my name, seeing it is wonderful?" (13:18 ESV).

This is a powerful promise to you right now no matter what you are facing. In Christ, you have the ultimate Counselor. You can pour out your heart as you lay that bag of flour at His feet. He is good. He is in control. He is for you. He is Wonderful. That's a promise.

The Things We Believe about Ourselves

I love that we can pour out our pain before Jesus. We can tell him everything that has happened to us and know for sure that He welcomes us, He listens to us. But how do we change what we say to ourselves? How do we change what we see in the mirror each day? How do the promises of God hold us when the image we have of ourselves is distorted? Sometimes the greatest ongoing battle we face isn't dealing with what has been done to us but dealing with how that action has marred our own image of who we are in Christ. Unfortunately, many of us live with those distorted images every day of our lives.

When Barry and I started dating, we were living in Southern California. I love the beach and suggested that we take a picnic there

one Saturday. I was surprised when Barry showed up in long pants on an eighty-degree day. We drove to Laguna Beach, found a quiet spot, and spread out our towels. When I asked him why he wasn't wearing shorts, he hesitated for a moment and then told me that his legs were too skinny. His legs were not too skinny, but he had a painful memory of being called "egghead on a pogo stick" when he was only six years old. In reality, he had perfectly normal, lovely legs, but he'd been teased so much that the "skinny" label had lived on beyond the facts.

Be careful when you feel the freedom to ask someone a sensitive question, as you just gave that person permission to do the same thing.

Barry asked me why I was wearing a T-shirt over my swimsuit. I lacked his courage and held back from telling him the truth for some time. I made up an excuse about being sensitive to the sun, which was probably true as I'm Scottish and most of my trips to the beach as a child involved not a T-shirt but a sweater and a coat, but it wasn't the whole truth. The whole truth was that I was embarrassed by my body. When I "developed" as a teenager, I hated the fact that I got more attention from boys. It made me feel desperately insecure. To me, attention always carried a potential threat with it. One day in particular still makes me break out in hives!

We wore uniforms in our high school. Gray skirt, white blouse, gold and navy tie, and navy blazer. We all looked the same, so I could blend in. But one day our principal announced that on the coming Friday we could wear whatever we wanted. I wore jeans and a Mickey Mouse T-shirt and felt very cool . . . until I got off the school bus. One of the senior boys looked at me and said, "Wow, who knew Mickey had such big ears!" I could have died. I know that I turned the color of an overripe tomato as those around me laughed. I went straight to the school nurse's office and asked if I could borrow a cardigan. Now, I know that some of you are very proud of the gifts God has given you in that department, as you should be, but for me,

I felt ashamed. To me, it signaled that I was different, worth laughing at when the spotlight was turned on me.

That conviction was engraved at an even deeper level when I was cast as the lead in our school's production of *West Side Story*. I didn't want the female lead part of Maria, but my music teacher, unaware of my fear and self-loathing, insisted. Our dress rehearsal before the opening night was in front of the entire school. Maria sings so many beautiful songs like "Tonight" and "Somewhere," but I felt as if the world caved in on me when I began to sing the classic "I Feel Pretty." I was halfway through the song when a boy yelled out, "Well, you don't look it!" The entire assembly hall burst out laughing. I stopped singing, frozen to the spot, everyone's eyes on me. The whole thing probably lasted for only about thirty seconds before the conductor of the school orchestra moved on to the next song, but it felt like an eternity. I had been publicly labeled "not pretty." That's how I saw myself, but having it confirmed, at least in my mind, in front of four hundred students was like having the label tattooed on my soul. If you'd traveled all the way to the basement of my fears, you'd have found this foundation stone: there is something wrong with me.

It has taken years for me to be able with the help of the Holy Spirit to look in the mirror and love the person I see there on good hair days and bad hair days. Because I work in television, I have a wonderful makeup artist who can cover up the guess-who-didn't-sleep-very-well-last-night look in the studio, but I want you to know that when I take it all off at night, I now see a woman Jesus loves. That's what I want for you too. Let me ask you to consider a few questions before I share three of the most powerful promises in God's Word.

What does your foundation stone say?

What are the labels you've worn for so long that it would be hard to describe yourself without them?

How could the promises of God help you hold on when you want to let go?

If you feel unloved, how does the promise of God's love impact you?

If you believe you are not and never will be enough, how could the promise of God's grace and strength impact that belief?

If you believe you'll always be plagued by anxiety, how does the promise of God's peace break through that conviction?

If you believe there's no plan for your life, how could the promise of God's presence and plan speak to that belief?

Grab Hold of His Promises

When I first read the Charles H. Spurgeon quotation at the beginning of this chapter, it felt a little rude, particularly this part: "Go immediately to His throne and say, 'Do as You promised.'" I thought, *Who am I to tell God what to do?* But on further reflection, I thought, *Why would God give us so many promises if we're not supposed to grab hold of them and hold on for dear life, remind Him of them, and remind ourselves too?*

The year 2020 highlighted for us that everything can change in a moment. Things we knew for sure one day were gone the next. Things we counted on as normal, such as getting together with our family at Christmas or birthdays, were no longer a right; they were a privilege with very specific guidelines and restrictions. People lost jobs, homes, loved ones, financial security, and so much more. As I told you earlier, at my lowest point in that year, I made a fresh commitment to dive deep into the Word of God and know for sure what has not and will not change. A steady diet of the evening news and the craziness of social media will give birth to anxiety and fear, but a steady diet of the promises of God will give us an immovable place to stand no matter what else is shaking. Let's dive in to what God has promised and how those promises can help us to hold on.

Some human promises are conditional, dependent on circumstances, or made to spare someone's feelings.

"Will I lose weight on this plan?" "I promise you will if you stick to it."

"Will you be coming home for Christmas?" "I promise I will if I can."

"Do these pants make my butt look big?" "I promise they don't." Jesus, take the wheel!

It's so important not to put God's promises into the same category as anything that has ever been promised to you before. God's promises are 100 percent trustworthy, 100 percent of the time. They are not conditional, they don't depend on circumstances, and they are true. The promises of God depend on God Himself, and He cannot lie. "For no matter how many promises God has made, they are 'Yes' in Christ" (2 Cor. 1:20 NIV).

God's promises don't always make sense to us in our timeline, but never, ever allow that to make you doubt that you can trust them. There are over seven thousand promises in the Bible, but for our purposes here, I want us to look at three key promises that hold us when we are struggling to hold on by ourselves.

Promise One: Nothing Can Separate Us from God's Love

Let's just start with what could arguably be called the most important promise of all, the promise of the love of God. When Paul wrote to the church in Rome, he said this: "And I am convinced that nothing can ever separate us from God's love" (Rom. 8:38).

The Greek word translated as "convinced" has a much bigger story to tell. In the Greek perfect tense, it can be understood as "I have become and I remain convinced."[2] This is very significant for us. What Paul is saying is that when he came into relationship with Christ (which if you remember was a pretty dramatic conversion in Acts 9), he was convinced that nothing and no one could ever separate him from God's love. Now, almost twenty years later, Paul

writes this letter having been through some devastating times and makes the statement that he is still absolutely convinced that nothing, nothing can separate us from God's love.

It would have been easy for Paul in the first flush of relationship with Jesus to make such a statement. He actually came face-to-face with the risen Christ on the road to Damascus. Blinded by the light of Christ's presence, he asked, "'Who are you, lord?' . . . And the voice replied, 'I am Jesus, the one you are persecuting!'" (Acts 9:5). From that dramatic conversion, he was all in, sold out to Christ.

Life for Paul from that moment on was one challenge after another. He was beaten, imprisoned, stoned and left for dead, starved, and shipwrecked. But having walked through all of that, he speaks to us right now and says, "I'm still convinced!" There is nothing that can separate us from God's love.

Not divorce.

Not cancer.

Not bankruptcy.

Not failure.

Not self-doubt.

Not betrayal.

Add your story in here.

There is nothing in heaven or on earth or under the earth that can separate us from God's love. That's a foundational promise.

Promise Two: Everything Will Work Out for Our Good

One of the things that brings anxiety and makes us panic is when life feels out of control. If we live with the conviction that because God loves us, He will orchestrate the details of our lives in a way that makes sense to us, we will be disappointed and disillusioned. More than that, we'll be tempted to believe that things have gone terribly wrong. We'll be tempted to let go. Romans 8:28 is one of the most quoted verses of Scripture but often one of the least understood.

And we know that God causes everything to work together for the good of those who love God and are called according to his purpose for them.

On a quick read, it can sound as if everything will *be* good and *feel* good to those who love God, but that's not what the text says. When we read on, we get a better understanding.

For God knew his people in advance, and he chose them to become like his Son, so that his Son would be the firstborn among many brothers and sisters. (v. 29)

The purpose of our lives on the best days and the worst is to become more like Jesus. That's the goal of our lives, to become more like Jesus. The promise of Romans 8:28 is that no matter what happens to us, God will bring good from it. It doesn't say that everything will be good, because clearly that's not true. But nothing is wasted by God. You have not wept one single tear that fell to the ground unnoticed.

One of the steps in my own healing has been thanking God for this promise. I've consciously brought all the broken pieces to him: my father's death by suicide, my depression, my month in a psychiatric hospital, my failures as a wife, a mum, and a friend. I've laid it all at His feet.

Would you do that? Would you as an act of faith bring all the parts of your story to God and thank Him that He has promised to bring good from everything?

We can choose to live by promises and not by explanations. Warren Wiersbe says, "Living by faith means obeying God's Word in spite of feelings, circumstances, or consequences. It means holding on to God's truth no matter how heavy the burden or how dark the day, knowing that He is working out His perfect plan. *It means living by promises and not by explanations.*"[3]

So we are held by the powerful promise of the love of God. We are held by the promise that God will bring good from everything for those who love Him and are called according to His purpose. But if you're feeling a little weary, let's look at one final promise.

Promise Three: God Will Give Us New Strength

I love this promise so much because it's a promise for the long haul. It gives us strength for, as Eugene Peterson wrote, *a long obedience in the same direction*. It's the promise that has given me strength all along.

> But those who trust in the LORD will find new strength. (Isa. 40:31)

I love this verse as it's translated in the Amplified version.

> But those who wait for the LORD [who expect, look for, and hope in Him]
> Will gain new strength *and* renew their power;
> They will lift up their wings [and rise up close to God] like eagles [rising toward the sun];
> They will run and not become weary,
> They will walk and not grow tired.

As a teenager, I grew up with the King James Version of this verse.

> But they that wait upon the LORD shall renew their strength.

I took that very literally and thought I had to sit and wait for God to give me new strength. It was a long wait, and nothing much happened. I read this text very differently now. "To wait" means "to *hope*," to look to God for everything. I've become like a God-stalker! I talk to Him all the time. I read His Word and meditate on

136

His promises, trusting that He is holding me, and I am holding on to Him. The more I know about God, the bigger He is. It's like one of my favorite passages from C. S. Lewis's *Prince Caspian*:

> "Aslan," said Lucy, "you're bigger."
> "That is because you are older, little one," answered he.
> "Not because you are?"
> "I am not. But every year you grow, you will find me bigger."[4]

I love that! The closer we get to Jesus, the bigger He is in our lives and the more we understand and trust His promises. There are so many promises we could have unpacked in this chapter, but I'm praying that these three promises will hold you tight when you are tempted to let go. You can drop your bag of flour and worship at His feet. Remembering . . .

Nothing can separate you from God's love.

Everything will work out for your good.

God will give you new strength.

Stay strong. These are God's promises!

HOLDING ON
TO HOPE

1. "Fair" doesn't live here, but Jesus does.

2. God will never fail you or abandon you.

3. God's promises are 100 percent trustworthy—
 100 percent of the time.

Father God,
Thank You for Your promises.
Thank You that I am being held.
Amen.

7

Held by the God Who Rescues

But I trust in your unfailing love.
 I will rejoice because you have rescued me.
I will sing to the LORD
 because he is good to me.

<div align="right">Psalm 13:5-6</div>

Love falls gently on each wound like snow upon the frozen
 ground.
And life that seemed a distant dream will waken in the
 promised Spring.

<div align="right">Sheila Walsh</div>

IT WAS AN UNUSUALLY COLD NOVEMBER NIGHT as Christian and I hurried back to the car from the grocery store. It felt as if it could snow, a sight we rarely see in Texas.

Suddenly, he stopped. "Mom, do you hear that?" he asked.

I stopped and listened. At first, all I could hear was the traffic rushing past, but then I heard it. It was faint, but I could hear something chirping on the ground.

"Where do you think it's coming from?" I asked.

"I think it's under this truck," he said.

We both got down on our hands and knees and looked underneath. It was hard to see at first, with the only light coming from the cars driving past, but there it was, a tiny baby bird resting against one of the tires. It was so little, probably recently hatched. Assuming it had fallen out of a nest, we looked to see if we could find where it might have fallen from or find a mother who might be looking for her baby. Nothing, no other bird sounds. We knew we couldn't leave him there. Whenever the owner of the truck returned and backed out of his parking spot, he would unwittingly run over him. We decided that we'd take him home and determine what to do from there. Christian went into the store and asked if we could have a small cardboard box. When he returned with the perfect little box, he shone the flashlight from his phone onto the baby bird as I reached under the truck. Picking him up was quite easy, as he was so little and seemed frozen to the spot. I placed him carefully inside the box, and we drove home.

I set the box down by the fire in our den and showed Barry our new little friend.

"What are you going to do with him?" he asked. "He must be hungry."

Christian did a little online research and read the results aloud. "He needs to be fed every two to three hours, from a dropper or a syringe. Scrambled eggs, we can feed him runny eggs."

I wasn't sure that would work, but it did. Every two hours when I opened the box, there he was, mouth wide open, waiting for the next course on that evening's menu. After we went to bed, I set my alarm at two-hour intervals. At first, I hoped he might decide to sleep through the night, but no, mouth open wide at 2 a.m., 4 a.m., 6 a.m., and 8 a.m., right on schedule. We named him Chirp.

I knew we couldn't and shouldn't try to raise a baby bird. Chirp needed to be with his own kind. We discovered there was a wildlife

sanctuary about an hour from our home. So that morning Christian and I drove to the sanctuary. What we saw inside was unforgettable. This particular wildlife rescue cares only for birds, all sorts of birds. As we waited for someone to help us, I was captivated by the variety of birds inside. Many were in large cages that mimicked their natural habitat, but some were flying around freely inside the farm building that housed the sanctuary. There was a white pelican, a blue and gold Macau, owls, hawks—quite a dazzling display of every kind of feathered friend. Soon a young man came over to help us. I opened the box and showed him Chirp. He assured us that they could care for him and, when he was strong enough, that he could be returned to the wild. I asked him what percentage of the birds are able to return to their natural habitat. He told us that about 80 percent are able to be released. The other 20 percent have imprinted on humans or their injuries are too debilitating for them to be able to care for themselves in the wild, so the sanctuary becomes their permanent home. I thanked him, and as I turned to leave, I saw a small barn owl perched beside a hawk, a sight you wouldn't normally see in nature.

"Do owls and hawks usually get along?" I asked.

"Rescued ones do," he said with a smile.

I thought about that for a long time.

Being rescued changes you.

Being rescued is personal.

Being rescued can be painful.

Being rescued is being held.

The Pain of Rescue

I don't imagine that the owl that had lost most of its right wing or the hawk with a broken back would have welcomed the circumstances that brought them to the bird sanctuary. At the time, what was happening was cruel and painful, but their rescue changed everything. They were safe now. They had a warm place to live and food to eat.

They had even found a friend that at one point would have been seen as an enemy. It was a new normal.

It would seem to make sense that tragedy precedes rescue. You don't have to rescue a child who has fallen through the ice unless the ice has given way beneath them. A family doesn't need to be rescued from a burning house unless the house is on fire. Those kinds of rescues make the evening news, but what about the tragedies that never make the news? What about the tragedies that are held inside? What if you feel right now like the ice is cracking underneath you but no one sees it? What if you feel like the house is burning all around you but no one else feels the heat or smells the smoke?

I often wonder how many people sit in church Sunday after Sunday barely alive on the inside, longing for rescue but having no idea how to ask for help or if help is even available. I did it for years. It wasn't as if I'd done something wrong and was in trouble; it was that the trouble was in me. I remember sitting outside one cold morning, snowflakes falling all around me, too tired to read my Bible or even take in what I might have read. All I could pray was, "Help me!" I had no idea what that help would look like, but I would never have signed up for what was just around the corner. That same two-word prayer was on my lips that first night in the hospital.

If you'd sat with me on the floor of my room that night and told me that what was happening to me at that very moment was an answer to my prayer, part of God's rescue plan, I wouldn't have believed you. Everything I was experiencing, everything I felt and thought was true, would have made that feel impossible. If this was a rescue plan, it felt brutal. As I flipped through chapters of my life in my mind, it seemed as if any puzzle pieces I had were being incinerated before my eyes. My prayer for help had resulted in my greatest nightmare, a psych hospital. It's hard to adequately express why I was so terrified of that place. I knew very little about the time my father had spent in our local asylum. I knew that he had been heavily sedated at times. I knew that many days he sat with his head

in his hands and wept. I knew that he had undergone electric shock therapy before he drowned himself. But the rest was a mystery that my young mind was only too quick to fill in with dark, disturbing images and nightmares. Nightmares that had me ending up just like my dad. One evening solidified what I had already feared.

I was about sixteen years old and an uncle said to me, "You're just like your dad, Sheila."

I'm sure he meant it kindly. You have his brown eyes. You sing just like your dad.

That's not what I heard. What I heard was "You are damaged like your father. There is a crack in your soul, and one day, no matter how fast you run or how hard you work, you will break."

Now here I was, in the place of my nightmares, so I begged God to take my life.

"God, if you have one ounce of mercy left for me, please take me home. I can't do this. I'm too afraid."

I wanted out of my nightmare, but that was not God's rescue plan. His plan was to walk me right through it to the other side, never leaving me for one minute. I learned through that experience that our fear is often far more potent than the thing we are afraid of.

I remember hearing my friend Jennifer Rothschild speak about the difference between *participant grace* and *spectator grace*. There is a grace given by God to the one who is walking through a dark night that's different from the grace given to the one who is watching. I received that participant grace. Instead of the hospital being a place of nightmares, it was a place of comfort and understanding. It became a place of community for me, the community of the broken and unafraid. I smile now when I remember that the other patients made me the entertainment secretary. That should be the number one item on my résumé. Entertainment Secretary in a Psychiatric Ward. It's such a relief to fall off the shelf where you have kept yourself safe but alone and join those who love Jesus but don't have all the answers.

There was no going back to normal. God's rescue plan had a new normal. Being rescued changed me. Not only that, but His rescue included a depth of grace and glory and the pure joy of being held that nothing else could ever have provided. I don't say that lightly. I begged to die, and now I love to live.

> Love falls gently on each wound like snow upon the frozen
> ground.
> And life that seemed a distant dream will waken in the
> promised Spring.

I wrote that in my journal a few months later. The very season that felt like the coldest winter of my life was actually God's perfect plan of watering the life He knew was underneath the frozen ground. I want that life for you. I want you to know that although your story is different from my story, God is committed to your rescue.

> The LORD says, "I will rescue those who love me.
> I will protect those who trust in my name.
> When they call on me, I will answer;
> I will be with them in trouble.
> I will rescue and honor them." (Ps. 91:14–15)

I sit here at my desk thinking of you and what you might be facing right now. What can I possibly say that might give you real hope for your own personal rescue? I feel as if I'm just one note of hope in God's great symphony of rescue and redemption.

Held by God

> When you pass through the waters,
> I will be with you;
> and when you pass through the rivers,
> they will not sweep over you.

When you walk through the fire,
you will not be burned;
the flames will not set you ablaze. (Isa. 43:2 NIV)

Another note of hope came to me in the form of a new broken-yet-beautiful friend. Each week at Life Outreach International, I have the privilege of interviewing guests on our daily television show *Life Today*. Many of their stories leave a mark on my heart but few as deeply as Vaneetha's. To hear her whole story, I recommend you read her book, *Walking Through Fire*. There is layer upon layer of tragedy in her story, but the rescue she continues to experience today is beautiful. With her permission, I want to share just a little of what we talked about that day.

Vaneetha contracted polio as an infant, but due to a misdiagnosis, she lived in and out of hospitals for ten years. She faced endless bullying at school that made life unbearable, but she told me that life changed for her after she became a Christian. She had a fresh sense of purpose and belonging. The next few years were filled with joy and hope. Vaneetha graduated from college and then went on to Stanford for her MBA, where she met and married her husband.

Having miscarried three times, she was excited yet nervous when they discovered she was pregnant again. At the ultrasound, hoping to learn the sex of the baby, they found out it was a boy, but he had serious heart problems. It seemed the baby had only half a heart. The doctor told her that unless the baby had a series of three surgeries, the first one at birth, or an immediate heart transplant, he would live for only about two weeks. I can't imagine a newborn experiencing such an invasive surgery, but knowing that this was their only hope, they agreed.

The first of the three surgeries went well, and after eight days, Vaneetha was allowed to take Paul David, her baby boy, home. It was stressful caring for such a tiny one who had endured so much, but he was doing well. At an appointment when he was six weeks old,

a different doctor, not fully understanding all the complications this little one was facing, took him off most of his medications. Within a few days, their little boy died. This baby whom they had prayed for and fought for and who had endured so much in his short life was gone because of a doctor's mistake. Unspeakable pain. It was only when Vaneetha used the phrase that she had been "held by God" in the middle of her pain that I realized I had heard her story long before I ever met her.

I remember the first time I heard my friend Natalie Grant sing the song "Held." As she introduced it that night to a packed arena, she told us that it was based on a true story about the unbearable pain a young mother had walked through. A profound silence fell over the crowd as ten thousand women listened to this song. She sang, "And to know that the promise was when everything fell, we'd be held."[1]

I had no idea as I listened with tears pouring down my cheeks that night that I would have the privilege of interviewing that mom. I wasn't the only one in tears. Although the particulars of the story were unique to Vaneetha, the pain was not. Every woman in the arena had faced some sort of loss, and being held in the midst of the pain was a communal longing.

Vaneetha faced many losses. The eventual loss of her marriage and her health once more when she was diagnosed with post-polio syndrome, a cruel resurgence of the disease that robs the one affected of any progress they had made, as if the clock suddenly begins to spin backward in time. Vaneetha's body continued to break down.

Before the interview, I had been given an advance copy of her book. I underlined several statements that I wanted to ask her to unpack for our audience.

"When the worst happened to me, I was at first hesitant to draw comfort from the God who had wounded me. But I hid those doubts and hesitations from others. I feared that my disappointment with life and even with God would damage others' faith. But that was

simply not true. I needed to live transparently, showing others that we can't sidestep grief but must honestly go through it."[2]

She wrote about the way she felt when God rescued her in the midst of her suffering. "It is the peace of a glassy ocean with an undercurrent of powerful, relentless joy. It is breathless excitement and perfect trust. It is bone-deep courage built on the promise that God will never leave or forsake me."[3]

Those words rang true deep inside me, but I wanted to hear more from the place of her pain and her rescue. I can't imagine losing a child, but she had been there, and from the darkness of that place, she reaches out to you and to me to let us know that Jesus was there, that she was held—not only held but experiencing joy and perfect trust. There was no doubt left in my mind after we spent that afternoon together that when everything in her life fell, she was held. Her body seemed fragile, but the blazing hope in her eyes was unmistakable. It wasn't the experience of suffering that had changed her, but the presence of Christ with her in the suffering became her rescue.

God Can Be Trusted

I was halfway through writing this chapter when I felt as if a fresh wave of faith and understanding hit me. I was sitting in my den, morning coffee in hand, listening to the news. None of it was good, so I turned off the television and went downstairs and outside, our dogs in tow. I brushed the leaves off one of the chairs and sat down in our backyard with my coffee and my Bible. A quotation from William Penn that I had recently read came back to me in the quiet: "In the rush and noise of life, as you have intervals, step home within yourselves and be still. Wait upon God, and feel His good presence; this will carry you evenly through your day's business."[4]

"Step home within yourselves." That phrase had stayed with me. I'd never heard communion with God expressed that way. I also knew that I was in need of God's "good presence." I picked up

my Bible and turned to one of the blank pages at the beginning. I wanted to write down the quotation before I forgot it. I don't know if you write notes in your Bible, but I love to. I'll come across things I wrote years before, many dated, and I'll see how God answered prayers or gave me greater understanding on something I had previously struggled with. Most of the extra pages were full, but I had one page left. At the top was something I'd written ten years before from one of my favorite Scottish theologians, Robert Murray Mc-Cheyne. I read it over and over that morning. "When Christ delays to help His saints now, you think this is a great mystery, you cannot explain it; but Jesus sees the end from the beginning. Be still, and know that Christ is God."[5]

I knew that the Holy Spirit was speaking to me that morning. I also knew that I needed His help to fully understand what He was saying.

So I sat quietly in the morning air and reflected on the beauty and the severe mercy of rescue. I would never have signed on to God's plan, and yet as He has continued to put missing pieces of the puzzle of my life in place, I have been changed.

Suddenly, Tink, our fourteen-year-old Bichon Frise, made an unexpected leap from the grass onto my lap, quite a feat at that age. She knocked my Bible to the ground and a letter fell out. I picked it up and read it. It's pretty worn by now, as I've read it so many times over the years. It was written on March 5, 1995, three months after Barry and I were married. I had spoken a few weeks before at a conference and received a letter from one of the women who had attended. She told me that on her flight home, God told her twelve things about my life. I don't move in circles where I often receive a prophetic word from God, but as I read her letter, it brought me to my knees. The sense of God's presence made me feel as if I was kneeling on holy ground.

I read through each of the twelve sentences that morning as Tink went back to her regular sport of squirrel chasing. I was drawn back

over and over again to number seven: "I will provide the comfort and peace that you have been waiting for, for many years. Just concentrate on Proverbs 3, meditate on my words constantly, for out of the richness of my Word in you, there shall flow waters of life into people's lives." I turned to Proverbs 3 and to these verses in particular, which I've always loved:

> Trust in the LORD with all your heart;
> do not depend on your own understanding.
> Seek his will in all you do,
> and he will show you which path to take. (vv. 5–6)

Have you ever read verses like these, promises like these, and you underline them but struggle to know how to apply them? Or perhaps you have tried to apply them and nothing seems to be working? You say, "I want to know what God's will is, but how do I find it?" I'm asked that question more than almost anything else. So let's go back to the beginning of this proverb and read what precedes the promise.

> My child, never forget the things I have taught you.
> Store my commands in your heart.
> If you do this, you will live many years,
> and your life will be satisfying. (vv. 1–2)

Simply put, the will of God is in the Word of God. I know that sounds very simple, hardly breaking news, but it's the truth. When everything around us is shifting and changing, the Word of God remains steadfast. I would imagine that you're probably with me on that. God's Word can be trusted, 100 percent.

So what was this fresh wave of understanding that impacted me so strongly? It had to do with this one little word: *trust.* Whether we're in a peaceful place or a difficult place, what needs to happen in us so that we are utterly convinced that we are being held by the

Simply put,
the will of God
is in the Word
of God.

God who rescues? We have to trust. But I want to dig deeper. What does it mean to trust God when we are longing to be rescued? What does that look like?

If you look up the word *trust* in most Bible dictionaries, you'll be directed to *faith*, as if they are one and the same. In the *HarperCollins Bible Dictionary*, we read, "Faith is related to trusting God to provide extraordinary help in desperate circumstances."[6] I love that, but trust is more than that. It's a daily confidence, not just in desperate circumstances but in any situation, because we are convinced that God can be trusted. Trusting God is not about ignoring our feelings or reality. It's not about pretending that everything is okay when it's not. It's not about trusting God for a certain outcome but rather being sure of Christ's presence no matter the outcome. It's about resting in the care of the One who loves us and is for us, believing that no matter what happens, God is with us and committed to our good, committed to our rescue.

If you and I with the help of the Holy Spirit could grasp hold of this one truth, that God can be trusted 100 percent of the time, it would change our lives. If that unchanging truth anchored our lives, then no matter how things seem, even if we feel we've been left flapping alone like that little bird under the truck, we would know that we are being held by the God who can be trusted to rescue His people.

> Think about Noah, who was told to build a boat the length of four football fields in the middle of the desert and no one had a clue what a boat was (Gen. 6–8).
>
> Or Abraham and Sarah, who were told that they would have a son when Abraham was a hundred years old and Sarah was ninety (Gen. 21).
>
> Or what it must have been like for seventeen-year-old Joseph. God had told him in a dream that his family would bow down before him. It didn't look good when he was at the bottom of an abandoned well (Gen. 37).

Or think about Daniel, thrown into a pit with lions, with the entrance sealed, and left to be torn to pieces (Dan. 6).

Or Jonah, rebelling and on the run from God, tossed into the sea and swallowed by a giant fish (Jon. 1).

Or Ruth, recently widowed, following her bitter mother-in-law to a land where she knew neither the language nor the people (Ruth 1).

Or Paul and Silas, thrown into prison after they'd been stripped and beaten with wooden rods (Acts 16).

Greatest of all, think of Jesus, betrayed, beaten, and executed yet risen again to become the Rescuer (John 19–20).

God's love story is all about rescue. It doesn't happen on our schedule or the way we would have written it, but we can trust who He is. If there ever was a moment when we needed to grasp hold of that truth, surely it is now.

As I sat in my garden that morning, I felt as if God had pulled back the curtain for a moment and shown me something that really matters for those of us who love Jesus. Things are going to get crazier in our world, but we can trust Him. In His way and in His time, He is the God who rescues His children.

> I said to myself, "Relax and rest.
> GOD has showered you with blessings.
> Soul, you've been rescued from death;
> Eye, you've been rescued from tears;
> And you, Foot, were kept from stumbling." (Ps. 116:7–8
> Message)

As I finished writing this chapter, it began to snow. We had not had any decent snow in Dallas since 2010, so I went outside to feel the snowflakes on my face. There is something so quiet about snow.

If He is the God
who rescues the
tiniest of birds,
He will rescue you.

As I watched our little yard become coated in a blanket of white, I prayed for you.

> I fall to my knees and pray to the Father, the Creator of everything in heaven and on earth. I pray that from his glorious, unlimited resources he will empower you with inner strength through his Spirit. Then Christ will make his home in your hearts as you trust in him. Your roots will grow down into God's love and keep you strong. And may you have the power to understand, as all God's people should, how wide, how long, how high, and how deep his love is. May you experience the love of Christ, though it is too great to understand fully. Then you will be made complete with all the fullness of life and power that comes from God. (Eph. 3:14–19)

I want to say to you, my dear friend, that God's Word will never fail you.

Remember that Jesus sees the end from the beginning.

Your life is not out of control.

God is still writing your story.

God has a good, strong hold on you.

He can be trusted.

If He is the God who rescues the tiniest of birds, He will rescue you.

HOLDING ON
TO HOPE

1. When everything around you is shifting, God's Word remains steadfast.

2. God is committed to your rescue; it's a promise.

3. God can be trusted 100 percent of the time, and your life is not out of control.

Father God,
When everything around me is shaking,
I look to You as the God who rescues.
Amen.

8

Held by the God of Miracles

The faithful love of the LORD never ends!
His mercies never cease.
Great is his faithfulness;
his mercies begin afresh each morning.

Lamentations 3:22–23

Miracles in fact are a retelling in small letters of the very same story
which is written across the whole world in letters too large for some
of us to see.

C. S. Lewis

FOR A FAMILY OF THREE, we have had a ridiculous number of
pets. When I first met Barry, I had a ragdoll cat named Abigail. She
was beautiful and sweet to me but took an instant dislike to him,
so much so that she would hide behind pieces of furniture, wait for
him to pass, and then pounce on his leg like a ninja warrior. After
we married and Abigail the Terrible had gone to live with an "aunt,"
we adopted a golden retriever named Bentley. We adored him, but he
had a very nervous stomach. I remember driving into Laguna Beach
(where we lived at the time) with the top down on my car one day
and a motorcycle roared up beside us. Let me simply say this: that

did not go well with Bentley's digestive system or my car. Then we had a son, and with a son come weird and wonderful pets. He had a lizard that needed to be fed live crickets as it lay in its hammock. He had a snake called Ramen the Danger Noodle that had to be fed frozen mice. (On a sidenote, after Christian headed off to college, I took what I thought was a popsicle out of the freezer one day only to discover that it had a face and a tail. Note to self: clean freezer out more often.) He had his fish Red, in addition to two aquariums, one freshwater and one salt. He had a small red bird named Amelia Earhart, which turned out to be a sadly fitting name, as she flew out the window one morning and we never saw her again. He had a jenday conure (a small parrot) named Grace, who would hop off her perch, run across the floor from the den to my office, and hop up on my shoulder. He had turtles and frogs and a hamster named Hamtaro. Then we entered the land of normal human beings and got him a dog.

Christian asked us one night if we could have a family meeting. I was intrigued. He asked us not to respond until he had finished speaking. We agreed. His announcement was short and simple: "I need a dog."

I told him I'd heard many people say they *wanted* a dog, but few had said they *needed* a dog unless to help with a disability. He immediately clarified his point.

"I'm an only child. I need someone to talk to."

"But you can talk to us!" Barry said.

To which Christian responded, "I mean *about* you."

Excellent point. We got him a dog the following weekend.

The only real challenge about having a dog was what to do with her when we traveled. Fortunately, we have two darling friends, Ney and Mary, who love dogs, so they agreed to take care of our dog, Belle, and Hamtaro the wonder hamster when we were on the road. I can't think of two women I love and admire more than Ney and Mary. They are loyal, faithful, and hilarious friends. If Ney tells you

that she will do something, she will do it to the nth degree. Each weekend when we picked up Belle, you would have imagined that she'd been attending finishing school in Switzerland because her manners were so refined. Even Hamtaro seemed less inclined to mess up his cage. But one weekend it all went terribly, hysterically wrong.

I'll tell the story to you as Ney and Mary relayed it to me. When they got up on Saturday morning, the catch on Hamtaro's cage was open and he was gone. Instant panic! They put their dog, Bailey, and our dog, Belle, in a room so they could search the house. They divided the house up into sections like a finely tuned forensics team. When they met back in the den at noon, there was no good news. Where on earth had Hamtaro gone? They knew how much Christian loved his hamster, so they called for backup. Three of my dearest friends from my days touring with Women of Faith all lived just a few miles apart at that time and so they responded to the call. The group convened in the kitchen. All options were discussed.

Could they buy another hamster that looked like Hamtaro?

Could they say Hamtaro had joined Red in New York?

Should they buy Christian another dog and hope he didn't notice that he was short one hamster?

Finally, after eight exhausting hours, Mary cried out, "I can see him!" Everyone rushed into the laundry room. "He's behind the dryer. He's not moving. He might be dead," she said in a hushed tone. They paused to pray . . . I kid you not. Then Mary asked a question that just illustrates how nuts we are as a group of friends but also the size of her heart.

"Okay," she said. "It doesn't look good. We're going to have to pray for a miracle. Ney, get the olive oil! But if he's really dead dead . . . does anyone know if PetSmart does autopsies?"

Autopsies! On a hamster! I laughed until I cried.

I'm happy to tell you that Hamtaro was alive and kicking, even though he had one of Ney's socks hanging out of his cheeks. When Mary finished telling me the story, she said, "It was a bona fide

miracle, I'm telling you! That hamster once was dead but now he is alive!"

To Believe or Not to Believe

On the subject of bona fide miracles, I don't have a lot of experience with them. I was raised in a small Baptist church in Scotland, and miracles were things that happened a long time ago. They were things that we read about in the Bible that happened when Jesus was on earth. Occasionally, I would hear about miraculous things that were still happening, but they always seemed to take place in Africa or India, never where I lived. As a young woman, that made me very sad. Whenever I walked past someone in a wheelchair or anyone who was struggling physically, I ached to be able to pray for them and see them miraculously restored. I simply didn't have the faith for it. I judged myself and felt as if I was letting God and those who needed healing down. One verse in particular condemned me: "I tell you the truth, anyone who believes in me will do the same works I have done, and even greater works, because I am going to be with the Father" (John 14:12).

The same works and even greater? Jesus healed the sick, restored sight to the blind, raised the dead. How on earth would I be able to do not just those things but even greater ones? It seemed impossible, and yet Jesus said it so I couldn't dismiss it. I struggled with that verse for a long time. It was like there was a missing piece in the puzzle of my faith and I couldn't find it. We'll come back to this in a moment because I understand this verse now in a way I never did before.

I don't know what your own thoughts are on the subject of miracles. I don't know whether you're part of a church tradition that embraces and expects them or one that has placed them firmly in the past. You might not be part of a church family at all. You may place the very idea of miracles in the same category as fairy tales and the Easter Bunny. You may also be one who has been damaged

by the promise of a miracle that didn't happen, and it's left you wounded and cynical.

Full disclosure. I believe in miracles. I believe that we haven't even begun to scratch the surface of who God is. I believe that God wants to touch our lives and heal our brokenness. I believe in the power of the risen Christ, alive and working in ways we can't even imagine.

I also believe that there has been a lot of damage done in the name of Jesus. Before I put one word on the page for this book, I asked the Holy Spirit to help me bring clarity and truth to those who love Jesus or are seeking to know Him but are struggling with experiences from the past. I want you to be free from anything that any man, woman, or false doctrine has imposed on you that has blurred your vision of who Jesus is. When I thought of those who might be struggling to hold on, those tempted to let go of faith, I wondered how much of that might have been caused by damage done to their souls. Let's face it, there's some strange stuff out there. Let me take you with me for a few moments to a couple of the places that were confusing to me and then to what I now know and believe with all my heart.

He Did What?

When I was a student in seminary in England, I was invited to be the vocalist at a three-night healing crusade. I had never been to anything like that before. I didn't know the evangelist, but I met him in the pastor's study before the service, and he was very kind and welcoming. I was excited to see what God might do that night. I wasn't a skeptic at all. I believed then as I believe now that anything is possible with God, and I longed to see His power in the lives of those who needed healing.

The crusade was being held in a small church in St. Albans just north of London. I watched as people poured into the building that first evening, a mixture of hope and doubt. I think that is probably always true when a crowd gathers to see what God might do. We

I believe in the power of the risen Christ, alive and working in ways we can't even imagine.

long to hear His voice, to know that He sees us, yet some of us hold back, perhaps because we've been disappointed before. The very act of being present in church speaks to the longing we have to know that we are seen, held, and loved by God. Will the preacher, the teacher, help us see Jesus?

After my part in the program that evening, the evangelist got up to speak. He gave a short message and then moved closer to the edge of the platform to begin to pray for people. Then closer and closer. I don't know whether the lighting was bad, but suddenly, to the horror of everyone in the room, he fell off the platform and had to be taken on a stretcher to the local hospital. I wish I was making this up, but I'm not. The entire crusade had to be canceled, as he'd broken his leg and fractured two ribs. I watched the crowd leave the church that night as confused as I was. No one knew quite what to say. Who prays for the healer to be healed?

My next brush with an invitation to the miraculous happened after I'd written my first book in the US. My publishing company invited me to attend the conference for what used to be called the Christian Bookseller's Association, where different publishing companies presented their new books and authors for the upcoming season. I had been given a time slot to sign books, but I went to the convention floor early to get an idea of what was going on. While I was wandering up and down the aisles looking at the various displays, a man stepped out of his booth, where he was taking orders for paintings, and asked if he could pray for me. I never turn down prayer, so I said that would be lovely.

Before he prayed, he explained that he had what he described as a miraculous prayer gift. When he prayed, gold dust would descend from heaven and fall on the one he was praying for. Wow! I'd never heard of anything like that. After his prayer, he asked me if I would push up the sleeves of my sweater. That seemed a bit odd, but I did. He was very excited to point out little sparkles on my arms. I thanked him and didn't have the heart to tell him that the sparkles were from

my body lotion. Should I have told him the truth instead of letting him think it was a miracle? I felt so bad the rest of the day. But of all my encounters with those who promised miracles, nothing grieved me as much as the next one.

I'll Worship Him from Here

I had been invited to sing at a youth convention in Hawaii. The guest speaker was an evangelist from Africa. When he took the stage on the second night of the conference, he made a stunning statement. He told the crowd that God had made it clear to him that every single sick person with any kind of infirmity present that night was going to be healed. You could sense the level of faith rise in the room. I was scanning the crowd for one person. I'd met him the previous evening. I'll call him John. John had been in a wheelchair for fifteen years following a devastating car crash. I was so excited at the thought of John being able to stand up out of his wheelchair and walk.

After the evangelist's message, he began to pray for people. The tent was packed and noisy and a lot of people had come up to the front of the stage. I couldn't see where John was. At the conclusion of the prayer time, the evangelist was immediately escorted off the platform, out of the tent, and into a waiting car. The tent finally emptied. The only two people who remained were John and me. I walked over to his wheelchair with tears in my eyes. "Don't be sad, Sheila," he said. "I know God could have healed me, and until He does, I'll worship Him from here."

I'll worship Him from here.

The greatest miracle I saw that night was the faith of John. His faith was not in what he saw or experienced; his faith was in Christ alone. He knew without question that God could heal him, but he didn't love Him less because He didn't. Neither was he angry with the evangelist for promising something that didn't take place, although I have to admit I was. I think if you tell people so definitively that God

164

Don't hold on
to the miracle;
hold on to the
miracle worker.

is going to do something and it doesn't happen, you should at least have the decency to look them in the eyes and say, "I'm sorry." John didn't need or want that. His hope was in Christ, not in a physical miracle. He wasn't holding on to the miracle; he was holding on to the miracle worker.

As we talked late into that night, what I saw in him was that, despite fifteen years of broken dreams and suffering, he knew a depth of companionship with his wounded Savior that I was yet to discover. I was standing, but he was being held by the God of miracles.

Miracles Change Our Circumstances; Obedience Changes Our Hearts

If the title of this chapter had you imagining that I would tell story after story of physical healings, I'm sorry. That's not what I'm going to do here. There are some marvelous books that tell those stories. One of my favorites was written by my dear friend Lee Strobel. His book *The Case for Miracles* is one of the most inspirational books I've ever read. Lee was an award-winning editor of the *Chicago Tribune*, so his research and storytelling are first class.

The bottom line here for me is that I don't believe that miracles change our lives. They are a welcome invasion from heaven, and if you are in need of one right now, I pause here, join my heart and my prayers with you, and ask that it would be done in Jesus's name.

The hard thing about writing a book is that it's one-sided. I can't hear your voice. I can't hear your "Amen" or your "What did you mean by that?" or your "I don't agree with you." Perhaps when this book is published, we can become friends on my Facebook page, Sheilawalshconnects, and then we can talk. For now, I'll do my best to unpack what I believe.

When I say that miracles don't change our lives, this is what I mean. How many times have you heard or read of someone saying, "God, if you'll just do this, I'll follow you for the rest of my

life." Or "I'll never touch another drink if you get me out of this." Often when God comes through in miraculous ways, promises are forgotten.

Think of those who witnessed Christ's miracles when He was on earth. Many people saw them with their own eyes, and then they walked away. The most remarkable event that illustrates this point is recorded in John's Gospel. It's the story of Lazarus. You can read the first part of the story in John 11:1–32, but I want us to be there on the day when Jesus arrived in Bethany, where Lazarus had been in his tomb for four days. Lazarus and his sisters were some of Jesus's closest friends, so when Jesus saw the sisters' profound grief, He was deeply moved.

When Jesus saw her weeping and saw the other people wailing with her, a deep anger welled up within him, and he was deeply troubled. "Where have you put him?" he asked them.

They told him, "Lord, come and see." Then Jesus wept. The people who were standing nearby said, "See how much he loved him!" But some said, "This man healed a blind man. Couldn't he have kept Lazarus from dying?"

Jesus was still angry as he arrived at the tomb, a cave with a stone rolled across its entrance. "Roll the stone aside," Jesus told them.

But Martha, the dead man's sister, protested, "Lord, he has been dead for four days. The smell will be terrible." (John 11:33–39)

We understand Christ's tears for those He loved, but why was He angry? The word used in the original Greek is the same word that would be used for the guttural snort of a stallion about to stampede. Jesus was angry that death had ever invaded life. That was never God's original plan for us. Jesus knew that in just days He would face the cross and in rising again would defeat death forever, but His friend had died and His fury as He faced the tomb was fierce. I wonder, too, as He stared at the stone if He thought about what lay just ahead for Him.

This one miracle stands alone. Jesus had previously brought two people back to life, but both had been dead for only a day. I'll explain why that is so significant in a moment. One was the only son of a widow (Luke 7). The other was the twelve-year-old daughter of Jairus, a leader in the synagogue (Luke 8). Clearly, those were significant miracles, but such occurrences were not unprecedented. If you were a Jew living in Israel at the time of Christ, your understanding of death would have been very different from ours today. Because Jewish people did not believe in embalming bodies, people were buried the day they died. Two things contributed to the significance of the fact that Lazarus had been dead for four days.

First, at times people who had been placed in their burial tombs subsequently revived a few hours or a day later. They had been in a coma or some other medical condition that made it appear as if they had died. To protect against anyone being buried alive, someone would be on guard outside the tomb for three days listening for any sounds.

Second, Jewish mourning traditions taught that when a person dies, the soul or *neshama* hovers around the body for three days deciding whether to return or not. By the fourth day, the soul had permanently departed.

To everyone gathered outside the tomb that day, one thing was clear: Jesus didn't come when He got the message that Lazarus was sick and now it was too late.

When we read Lazarus's story, it seems strange at first that when Jesus hears that Lazarus is ill, He waits where He is for two days before He makes the one-day walk back to Bethany. Why wouldn't He come when He could have prevented Lazarus's death? I would imagine that was the whole point. No one could bring someone who'd been dead for four days back to life. No one had ever witnessed that. It would be a miracle beyond miracles.

Imagine that we are there that day, standing at the tomb with Mary and Martha and the other mourners. We can't believe what happens after they roll the stone away.

Then Jesus shouted, "Lazarus, come out!" And the dead man came out, his hands and feet bound in graveclothes, his face wrapped in a headcloth. Jesus told them, "Unwrap him and let him go!"

Many of the people who were with Mary believed in Jesus when they saw this happen. But some went to the Pharisees and told them what Jesus had done. (John 11:43–46)

Do you see the crowd's mixed reaction? Many believed, but some reported Jesus to those who wanted to have Him killed. That is astonishing to me. They just saw with their own eyes that Christ was the promised Messiah, for who else but God could perform such a miracle, but it wasn't enough to change their hearts. A miracle might change our circumstances, but worshiping from a wheelchair, from a sickbed, from the place of broken dreams changes our hearts.

How Can We Do Greater Things Than Jesus Did?

So let's go back to the verse from John's Gospel that felt like such a missing piece to me for so long: "I tell you the truth, anyone who believes in me will do the same works I have done, and even greater works, because I am going to be with the Father" (John 14:12).

If we look closer, we can see that Christ's declaration to his closest friends that evening actually came with its own explanation. Jesus said that greater things would be possible *because* He was leaving the earth. During His three years of public ministry, Jesus could be in only one place at a time. Once He had ascended into heaven, the Holy Spirit would be given on the day of Pentecost and greater works would be possible because of the Spirit's presence. My ESV study Bible says that "greater works" can also be translated as "greater things." The Amplified Bible unpacks the text this way: "I assure you *and* most solemnly say to you, anyone who believes in Me [as Savior] will also do the things that I do; and he will do even greater things than these [in extent and outreach], because I am going to the Father."

Think about this: in His lifetime, Jesus never preached outside of Palestine. Europe, Africa, and Asia had never heard of Christ. But on the day of Pentecost alone, more people came to faith in Christ on that one day than during His three years of earthly ministry. "Those who believed what Peter said were baptized and added to the church that day—about 3,000 in all" (Acts 2:41).

Now the gospel of Christ is being preached all over the world. The Word of God is blazing across the continents. Wycliffe Bible Translators give us the following statistics: "The full Bible is now available in 704 different languages, giving 5.7 billion people access to Scripture in the language they understand best. The New Testament is available in another 1,551 languages, reaching another 815 million people. Selections and stories are available in a further 1,160 other languages, spoken by 458 million people."[1]

What a miracle! Not only that, but you and I, filled with the power and love of Christ, can be His hands and feet to an aching world. Think of what the body of Christ is doing today. When we love our neighbor, feed the poor, care for widows, rescue those who have been trafficked, drill water wells in areas where there is no clean water, provide shelter for the homeless in Jesus's name, miracles *are* happening every day.

But what about you? As you think about your life as it is right now with all that's working well and all that's falling apart, do you see yourself as a miracle? I do. But it might mean looking at miracles in a different way.

Healed and Held

If we are new to each other through this book, I want you to know something about me. I am the least likely person to write a book, to stand on a stage and speak, or to be comfortable in front of a television camera. I walked in my sleep and had terrifying nightmares until I was eighteen years old. I was desperately insecure and tried

to stay in the background whenever possible. I always assumed that people were more comfortable when I wasn't around. I remember someone in seminary asking me one night why I walked into the student common room the way I did. I asked him what he meant. He said, "You always walk in with your head down as if you don't want to be noticed." Bingo! Realizing that I was actually drawing attention to myself by looking odd, I learned to fake it. I learned to make it look as if I was doing okay, but I wasn't okay. I wrote this in my journal one evening:

> I'm fine; the sun is shining.
> God is in the heavens.
> All is well with the world.
> I am dying; it is dark.
> God, where are You?
> Have You forgotten me so quickly?

I wonder if you've been there too? Perhaps you're there right now. It's a lonely place to live. If you feel as if you are just hanging on by a thread, I want you to know that there is help and healing for you. As I look at my life today, I know one thing for sure. I am a miracle. I am held by the God of miracles. So what happened, what changed? The change didn't happen because I suddenly became confident or took a self-help class. Not at all. I just reached out and touched the edge of His robe.

A woman in the crowd had suffered for twelve years with constant bleeding, and she could find no cure. Coming up behind Jesus, she touched the fringe of his robe. Immediately, the bleeding stopped.

"Who touched me?" Jesus asked.

Everyone denied it, and Peter said, "Master, this whole crowd is pressing up against you."

But Jesus said, "Someone deliberately touched me, for I felt healing power go out from me." When the woman realized that she could

not stay hidden, she began to tremble and fell to her knees in front of him. The whole crowd heard her explain why she had touched him and that she had been immediately healed.

"Daughter," he said to her, "your faith has made you well. Go in peace." (Luke 8:43–48)

Let me say one thing about this story up front. The first miracle this woman received was that the bleeding she'd been experiencing for twelve long years stopped. The greater miracle that day was that she was able to go in peace. This story has impacted my life, and I believe it will impact yours.

It's hard for us to understand what life was like for women in the ancient world. I don't think anyone needed Jesus's message of grace more than they did. Their freedoms were severely restricted by Jewish laws. They were basically confined to their father's and then their husband's home. We can assume that Mary and Martha weren't married and that their father had died, as they were living with their brother, but what about this woman? Because of her bleeding, she was ritually unclean by Jewish law. She must have lived alone, as anything or anyone she touched was also made unclean. Can you imagine what it must have been like not to touch another human being for twelve years? Never to be hugged, never to be held?

When she heard that Jesus was close by, she decided it was now or never. She broke so many laws that day. She should not have been in a crowd. Not only that, but a woman was never supposed to touch a man in public, not even her husband. But she was desperate, so she reached out and touched one of the four tassels Jewish men wore on the edges of their robe. Jesus immediately felt power leave Him. The disciples had no idea what was going on. Why would Jesus ask who touched Him when the crowd was so dense? It would be like asking in Target on Black Friday, "Who bumped into me?" But Jesus said that someone had *deliberately* touched Him. Someone had touched in faith. Now what was she going to do?

If she spoke up, she could be punished in a Jewish court, or she could just slip away and no one would know it had been her. Then after seven days, she could present herself in the temple and be declared clean, she could go back to normal life, she could, like me, just blend in. She had her miracle, but was she really healed? A miracle wasn't enough; she needed to be made whole. So she fell to her knees and told Jesus the whole truth.

Luke doesn't give us her name. All who tell her story refer to her as "the woman with the issue of blood." But Jesus renamed her. He called her "Daughter." Did you know that she is the only individual woman that Jesus ever called daughter? He owned her. In front of a crowd who would have judged her, He said, "She's mine." If she had slipped away and gone home with her miracle, she would have been healed but not held. Jesus said, "Go in peace. You are held."

That's my story too. Yes, I spent a month in a psych hospital with good doctors and medication that made a huge difference, but it was only when I fell on my knees at Jesus's feet and told Him the whole truth, poured out everything, that I was healed and held. It happened on a fall morning a week before I was discharged from the hospital, as sun was streaming through the stained-glass windows of a little church. I sat with a nurse in the back row feeling so alone. As the organist began to play the first notes of a familiar hymn, tears started to run down my face. I've known that hymn since I was a child. I used to sit beside my grandmother each Sunday, and when she would rise to sing a hymn, I would stand up on the pew beside her and bury my face in her coat because it smelled of her perfume. I felt so homesick that morning. There was no place to bury my head anymore. Then the congregation began to sing.

Rock of Ages, cleft for me,
Let me hide myself in Thee;
Let the water and the blood,
From Thy riven side which flowed,

Be of sin the double cure,
Save me from its guilt and power.

Nothing in my hand I bring,
Simply to Thy cross I cling.[2]

I had known the words for a long time, but that morning I understood them for the first time. There is a place to hide; there is a place to be held. It's the greatest miracle of all. On the day of my release from the hospital, my doctor called out to me from his office window as I made my way to my car. He asked me this question: "Sheila, who are you?" I turned and smiled as I replied, "I am a daughter. A daughter of the King of Kings."

Have you ever done that? It's not enough to show up in church week after week, dragging the same baggage in and dragging it home again. When the pain of remaining the same is greater than the pain of change, then we are finally ready to change. You get to tell Jesus the whole truth, everything. The greatest miracle after our salvation is being able to pour out our story at Jesus's feet and hear Him say, "Daughter."

HOLDING ON
TO HOPE

1. Miracles change our circumstances; obedience changes our hearts.

2. Reach out and touch the edge of His robe.

3. When the pain of remaining the same is greater than the pain of change, then we are finally ready to change.

Father God,
In faith and in obedience, I reach
out to You now for my miracle.
Amen.

9

Held by the One Who Changed Everything

Don't let your hearts be troubled. Trust in God, and trust also in me. There is more than enough room in my Father's home. If this were not so, would I have told you that I am going to prepare a place for you? When everything is ready, I will come and get you, so that you will always be with me where I am.

John 14:1-3

Fundamentally, our Lord's message was Himself. He did not come merely to preach a Gospel; He himself is that Gospel. He did not come merely to give bread; He said, "I am the bread." He did not come merely to shed light; He said, "I am the light." He did not come merely to show the door; He said, "I am the door." He did not come merely to name a shepherd; He said, "I am the shepherd." He did not come merely to point the way; He said, "I am the way, the truth, and the life."

J. Sidlow Baxter

HAVE YOU EVER HAD A DAY when every little thing went wrong? Not just one or two things but all the things. Where do I even begin?

177

Scene one. I slept in. Not always a big deal, but I was supposed to speak that morning at a Christian retreat about forty minutes away. I got ready quicker than any woman should, and Barry and I ran out the door and to the car. Have you ever tried to put mascara on in a rapidly moving vehicle? It doesn't usually end well. Traffic was light that morning, so we actually got to the retreat on time. I even had a moment to use the restroom and remove the black streaks on my forehead. All good so far, but the day had just begun. I met with the retreat leader just before I spoke, and she was clearly intrigued by my Scottish accent, as she introduced me as "Shrek in a dress." There's a visual for you.

Scene two. I spoke twice that morning, and then we left the retreat at noon and headed home. I had three television shows to tape that evening, but I had plenty of time to change and get to the studio by five. Yes, I know. It's not going to work out, is it? Halfway home we felt a big bump and the car began to swerve. We pulled over to see that one of the front tires was flat. Fortunately, just a few yards down the road was a Discount Tire. Barry drove the car at a slow crawl as I sang a couple of verses of "Rescue the Perishing." A sweet mechanic named Darryl looked at it and shook his head. "She's a goner," he said. "You're gonna need a new tire."

"Will that take long?" I asked, hopeful it wouldn't.

"I'll have you good as new in twenty minutes!" he said.

Just remember, this is scene two. It's not going to take twenty minutes.

An hour later, he gave up.

"You'll laugh about this later," he said, "but I can't get your tire off. I reckon that tire is on until Jesus returns. You'll have to have the car towed to the dealership."

Scene three. The car is being towed to the dealership, and Barry and I are in an Uber heading home. We're good. I still have enough time. I'm cutting it a little close, but I can do this. Of course I can't! It's scene three. When we get home, we can't unlock the front door.

We left through the garage, and because we were running late, we didn't unlock the dead bolt or the weighs-a-ton sliding lock inside the front door. We looked at each other in disbelief for a few seconds, and then I had an epiphany.

"We'll go through the garage!" I yelled in triumph.

"And how will we open the garage?" Barry, ever the skeptic, asked.

"With the garage door opener," I said as nonpatronizingly as I could.

"And where would that be?" he asked.

"In the . . . yep. In the car on the tow truck."

Scene four. It began to rain. Of course it did. Not a light drizzle but more like buckets of water being poured down from heaven. Why didn't you try the back door, you may ask, dear reader? It has the same locks as the front.

"I'm going to have to break a window," Barry said with a kind of Captain America vibe.

"Great idea!" I said.

Nope.

The good news, long term, is that our windows don't break. The bad news, that day, was that our windows don't break. By now my hair was stuck to my head like a bad toupee and my mascara was dripping off my chin.

Scene five. Barry remained at home attempting to see if anyone could help him get into the house through the garage. I got a car and arrived at the studio. I walked into the makeup room, where several of the staff were waiting for me. Silence. No one spoke. A lot of staring but no actual words. Finally, I found my voice and said to Krisha, my makeup artist, "Darling girl, all I can say is this: if you have ever desperately needed Jesus's help, you need Him more right now!"

We all burst out laughing. Some were on the floor. I looked like something that had crawled out of a swamp. (PS: Barry did manage to get into the house but still refuses to divulge his secret.)

When the Rain Won't Stop

Yes, we all have days like that. Days when nothing goes right. We laugh about them later with family and friends. They pass and life goes on. But let's be honest, there are hard seasons in life that seem to never end. You might be in the middle of one right now.

Your family might be falling apart and you can't do anything about it.

Perhaps you live paycheck to paycheck and if that's cut off, you'll be in a desperate place.

You might be struggling with anxiety and panic attacks.

You might be desperately lonely and find it hard to believe that will ever change.

Perhaps you're living with a chronic illness that never seems to get better.

Or what if the bottom line is this . . . you've just lost hope?

In the past year, I've become acutely aware of how little I understand about some of the issues people are dealing with every single day. It drove me to my knees. Day after day I knelt in silence in the Lord's presence. What is there to say that will touch the woman with cancer, the one who just lost her home, the one who is afraid to let her children leave the house because of the color of their skin, the one whose husband just walked out, the one whose kids are lost in the world of drugs, the one who is trapped in the maze of mental illness? It's painfully clear that not everyone is going to get the answer, the help, the hope they long for on this earth.

Then it became crystal clear to me, as clear as anything I've ever known.

Jesus.

Now before you write me off as being out of touch with reality, I've never been more in touch with reality. I am convinced that Christ is our hope no matter what happens in this world.

180

So be truly glad. There is wonderful joy ahead, even though you must endure many trials for a little while. These trials will show that your faith is genuine. It is being tested as fire tests and purifies gold—though your faith is far more precious than mere gold. So when your faith remains strong through many trials, it will bring you much praise and glory and honor on the day when Jesus Christ is revealed to the whole world. (1 Pet. 1:6–7)

Jesus is the hope for every man, woman, and child on this planet. If you're strong or weak, rich or poor, happy or sad, Jesus is your hope. Not in a "come to Jesus and everything will be all right" bumper-sticker way. No. In the radical truth that Jesus came to us to make everything all right eternally. There's no doubt that we will all lose some battles along the way. You know that to be true in your own life. But because of what Jesus has done for us, every single one who places their trust in Him will win in bigger ways than we can even begin to imagine right now. Hold on, for He is holding on to you.

I want us to take a fresh look at Jesus. As I've studied over the past months, I believe that the Spirit has given me new insight into things I didn't see before. Jesus changes everything, absolutely everything. You may know His story well or perhaps it's new to you, but come with me and let's walk with Him. It is a life-changing journey.

The Beginning of Hope

In his Gospel, Luke tells us about the night when Christ was born.

And there were shepherds living out in the fields nearby, keeping watch over their flocks at night. An angel of the Lord appeared to them, and the glory of the Lord shone around them, and they were terrified. But the angel said to them, "Do not be afraid. I bring you good news that will cause great joy for all the people. Today in the town of David a Savior has been born to you; he is the Messiah, the

I am convinced that Christ is our hope no matter what happens in this world.

Lord. This will be a sign to you: You will find a baby wrapped in cloths and lying in a manger." (2:8–12 NIV)

I wonder what you imagine when you think about that scene. I remember watching a nativity play in our church in Scotland one Christmas Eve. Everything went as planned until it came to the inn-keeper. The only line he had was "I'm sorry, but there is no room in the inn." That's all he had to remember, but when Mary and Joseph arrived at his door, he paused, then clearly having empathy for them, he said, "Oh, why not. Come on in. I'll make room!" The whole church erupted in laughter, as you can imagine, but Mary and Joseph stayed in character and made their way to the stable.

The traditional scene that we see on Christmas cards or in nativity sets with a stable full of animals isn't actually what happened when Mary gave birth to Jesus. It was a much more holy and significant sight.

The shepherds that the angels appeared to that night were no ordinary shepherds. The fields outside of Bethlehem were where a special group of shepherds raised the lambs that were to be sacrificed in the temple. They were called Levitical shepherds. These shepherds kept their flocks outdoors twenty-four hours a day, three hundred and sixty-five days of the year, but they would bring the ewes into a birthing cave to deliver their lambs.[1] Sacrificial lambs had to be spotless and without blemish (Exod. 12:5). So this cave was kept sterile for the arrival of newborn sacrificial lambs. When a lamb was born, it was immediately wrapped in clean cloths to protect it and keep it from imperfection and danger. Newborn lambs can be clumsy, so they were wrapped so that they wouldn't injure themselves on the jagged edges of the cave.

When the angels made their declaration to these Levitical shepherds, they said, "You will find a baby wrapped in cloths and lying in a manger." The shepherds knew exactly where to go. They went to their birthing cave and saw the baby Jesus, the spotless Lamb of God, swaddled in cloths, lying in a manger.

The profound symbolism of this is breathtaking to me. Jesus wasn't born surrounded by animals and hay and dirt and dust. No, our Savior was born in the place where every sacrificial lamb was born. Soon there would be no more need for lambs to be sacrificed because Jesus, the spotless Lamb of God, would be sacrificed once and for all for you and for me.

Another interesting and significant thing I discovered was this: when babies were born in those days, they were immediately washed with salt, a kind of antiseptic bath to remove any impurities.[2] So Joseph would have taken Jesus and washed his body with salt. This is just one more powerful illustration that Christ would be the sacrifice for all who place their trust in Him. In the Old Testament, the children of Israel were given rules as to how to offer a sacrifice to God: "Do not leave the salt of the covenant of your God out of your grain offerings; add salt to all your offerings" (Lev. 2:13 NIV). Christ, the greatest offering of all, was washed with salt.

Thirty-three years later, as the sacrificial lambs were being led into Jerusalem to be sacrificed, Christ, the Lamb of God, was being led out of Jerusalem to be the ultimate sacrifice for sin. "For you know that it was not with perishable things such as silver or gold that you were redeemed . . . but with the precious blood of Christ, a lamb without blemish or defect" (1 Pet. 1:18–19 NIV).

The Perfect Plan of God

There are over three hundred prophecies about Jesus in the Old Testament—fifty-five specifically about His birth, ministry, death, resurrection, and role in the church. He fulfilled every single one of them. Eight centuries before Jesus was born, the prophet Isaiah wrote this:

> He was despised and rejected—
> a man of sorrows, acquainted with deepest grief.

> We turned our backs on him and looked the other way.
> He was despised, and we did not care.
> Yet it was our weaknesses he carried;
> it was our sorrows that weighed him down.
> And we thought his troubles were a punishment from God,
> a punishment for his own sins!
> But he was pierced for our rebellion,
> crushed for our sins.
> He was beaten so we could be whole.
> He was whipped so we could be healed. (Isa. 53:3–5)

Have you ever wondered what Isaiah thought when he wrote that? He was describing in detail what would happen to Jesus hundreds of years before it would happen. Many of the prophets were given incredible revelations from God that they wrote down, but something life-changing happened to Isaiah. Do you remember what that was? Isaiah saw Jesus.

Christ appeared to Elijah, but he didn't recognize Him (1 Kings 19:7). (When the phrase *the angel of the Lord* is used in the Old Testament, it is referring to Christ, the second person in the Godhead.[3]) He appeared to Abraham, but he didn't know who He was (Gen. 18:1–2). Isaiah saw the Lord, and he knew who He was. "It was in the year King Uzziah died that I saw the Lord. . . . Then I said, 'It's all over! I am doomed, for I am a sinful man. I have filthy lips, and I live among a people with filthy lips. Yet I have seen the King, the Lord of Heaven's Armies'" (Isa. 6:1, 5). John confirmed this in his Gospel: "Isaiah said these things because he saw his glory and spoke of him" (John 12:41 ESV).

It will be quite something when we're all home one day and we understand the whole amazing redemptive story. When every single piece is finally placed in the puzzle, I know we will fall and worship. Christ came for one purpose. He came to pay the price for sin to give us a way back home to God our Father. He left the glory that Isaiah saw to be born to dirt-poor parents.

According to the law of Moses, a firstborn boy had to be brought to the temple in Jerusalem when he was forty days old and presented to the Lord. A sacrifice was brought so that the mother could be declared ceremonially clean. Wealthy parents brought a lamb as a sacrifice, but there was provision in the law for those who couldn't afford a lamb. "And if she cannot afford a lamb, then she shall take two turtledoves or two pigeons" (Lev. 12:8 ESV). So that's what Mary did that day. To anyone who saw her approach the temple, it would have appeared that a poor young girl was bringing two turtledoves. They wouldn't have understood that she was carrying the Lamb of God.

Bending Low to Lift Us High

We live in a world where people struggle for position and influence. Being called an "influencer" these days comes with a cash value. If you have enough followers on social media channels, advertisers will pay to be on your site. The life that Christ lived from beginning to end was the total opposite of that kind of self-promotion. His life was one of pure humility. Think about the day He was baptized. My friend Angie Smith wrote a beautiful Bible study called *Matchless: The Life and Love of Jesus*. She writes, "Picture the crowds staring as John wraps an arm around his cousin—the One whom the world had waited for. . . . For one split second, the weight of Jesus is being lowered and lifted by a mere man. . . . He came to lower Himself to lift us."[4]

I am stunned by the humility. The Son of God, the One who spoke the world into existence, being lowered into the water, trusting His cousin to hold Him. Never doubt this truth: the One who allowed Himself to be lowered did this so that you can be held forever. But Christ lowered himself even more on the cross.

We've talked a little about what took place on the cross, but I didn't realize until recently the awful significance of the fact that

Christ was crucified on the middle cross. John Calvin wrote, "By hanging Him in the middle, they gave Him first place as though he were the thieves' leader."[5]

To onlookers or passersby that day, Jesus looked like the ringleader of a bunch of crooks. Even more devastating, it looked like He was permanently cursed by God. Devout Jews coming from around the world for Passover turned their faces away from Him. Paul reminds us why: "When he was hung on the cross, he took upon himself the curse for our wrongdoing. For it is written in the Scriptures, 'Cursed is everyone who is hung on a tree'" (Gal. 3:13).

Martin Luther paints an even more shocking reality of what happened to Jesus during His crucifixion: "He bore the person of a sinner and of a thief—and not of one but of all sinners and thieves. . . . And all the prophets saw this, that Christ was to become the greatest thief, murderer, adulterer, robber, desecrator, blasphemer, etc., there has ever been anywhere in the world."[6]

> He was counted among the rebels.
> He bore the sins of many and interceded for rebels.
> (Isa. 53:12)

For the first time in all eternity, Christ was totally alone. From the cross, He spoke to His mother and John: "When Jesus saw his mother standing there beside the disciple he loved, he said to her, 'Dear woman, here is your son.' And he said to this disciple, 'Here is your mother'" (John 19:26–27). God the Father had turned away, and now Jesus was giving His mother to His friend. On the cross, He was no one's Son and He had no Father.

Whatever you and I face, we'll never be in that place. You are being held by the One who changed everything. You will never, ever be alone. You will always be loved. You will always be held by the One who lowered Himself to lift you up.

Laid in a Tomb

Just as that tiny baby was wrapped in cloths and laid in a manger, now Jesus was wrapped in cloths and laid in a tomb. If Christ's story had ended there, we'd have no reason to hope. He would have been a good, kind man, but we would still be lost and alone. Fortunately, the story was far from over. The largest piece of humanity's puzzle that had been missing since sin entered the world in the garden of Eden was about to be put in place once and for all.

Early on Sunday morning, Mary Magdalene went to the tomb with spices and ointments for Christ's bruised and bloodied body, only to discover that the stone had been rolled away. She ran as fast as she could to tell the disciples.

> Peter and the other disciple started out for the tomb. They were both running, but the other disciple outran Peter and reached the tomb first. He stooped and looked in and saw the linen wrappings lying there, but he didn't go in. Then Simon Peter arrived and went inside. He also noticed the linen wrappings lying there, while the cloth that had covered Jesus' head was folded up and lying apart from the other wrappings. (John 20:3–7)

I read a folktale about the significance of the cloth that had covered Jesus's head being folded. Supposedly, there was a tradition between a master and a servant. If a master was finished eating, he would wad up the napkin as a way of saying he was done. If it was neatly folded, it meant he was coming back. I love this story, but I've not been able to verify it in any Jewish literature. Jesus, however, made no secret of the truth that He was coming back! "Then Jesus began to tell them that the Son of Man must suffer many terrible things and be rejected by the elders, the leading priests, and the teachers of religious law. He would be killed, but three days later he would rise from the dead" (Mark 8:31).

Even his enemies remembered. The religious leaders panicked after Christ was placed in the tomb, and so they went to see Pilate. "They told him, 'Sir, we remember what that deceiver once said while he was still alive: "After three days I will rise from the dead." So we request that you seal the tomb until the third day'" (Matt. 27:63–64).

Earlier in His ministry, some of the religious leaders demanded that Jesus perform a sign, as if He were a circus performer. Jesus refused. He told them that the only signs they would get were one that had already taken place and one that was to come. "For as Jonah was in the belly of the great fish for three days and three nights, so will the Son of Man be in the heart of the earth for three days and three nights" (Matt. 12:40).

Luke, the doctor, remembered another detail about that resurrection morning. As the women looked inside the empty tomb, they encountered two magnificent angels. "The women were terrified and bowed with their faces to the ground. Then the men asked, 'Why are you looking among the dead for someone who is alive? He isn't here! He is risen from the dead!'" (Luke 24:5–6).

It's Only on Sunday That Friday Makes Sense

On Friday nothing made sense. For those who loved and had followed Jesus for three years, all their hope hung on the cross that day. What happened? What had gone wrong? Perhaps some of the watching crowd wondered if there would be a miracle. If He was who He said He was, would angels come down and rescue Him? They watched and they waited and then they heard these words: "It is finished!" The apostle John tells us, "Then he bowed his head and gave up his spirit" (John 19:30).

Finished! After everything He said, everything He did, it was over.

It was Friday, but then Sunday came! I can't imagine what that day must have been like for the women at the tomb. Jesus was gone.

189

They had watched Him die, but now He was alive? How do you even begin to process that? But what about Peter?

I've often wondered how Peter reacted to the news that Jesus was alive. He must have thought back to what Jesus had said to him on the night of their last meal together.

"Simon, Simon, Satan has asked to sift each of you like wheat. But I have pleaded in prayer for you, Simon, that your faith should not fail. So when you have repented and turned to me again, strengthen your brothers."

Peter said, "Lord, I am ready to go to prison with you, and even to die with you."

But Jesus said, "Peter, let me tell you something. Before the rooster crows tomorrow morning, you will deny three times that you even know me." (Luke 22:31–34)

Again, we see here that any suffering we go through has to first pass through the hands of Christ. This is not to say that God causes the suffering we experience, but none of those experiences are outside of His control. We live in a broken, fallen world, but God will use our suffering for His glory and to make us more like Jesus.

Satan had to get permission. Jesus told Peter and the rest of the disciples that Satan had asked to shake each one of them so violently that they would fall away. But then He turned His gaze directly to Peter. I can only imagine the compassion in His eyes as He told Peter that He had pleaded in prayer for him that his faith wouldn't fail him. When I read that passage as a young believer, I found it very confusing. Jesus prayed that Peter wouldn't fail, and yet Peter failed. He denied even knowing Jesus, not just once but three times. Did Christ's prayer fail? No.

Jesus said, "So when you have repented and turned to me again, strengthen your brothers" (Luke 22:32). Jesus knew that Peter would panic when everything got so out of control and it looked as if he

might be arrested too. Jesus also knew that Peter would turn around and come back to Him. The Greek word used here for "turned" is *epistrepho*, meaning "to go back, to turn around." I think it's a beautiful thing that at the same time that Jesus was telling Peter he was going to fail He was giving him a new commission: "strengthen your brothers."

Have you ever noticed in your own life that when you feel as if you've failed, that's all you remember? A teacher may have told you that both your children are doing really well in school; it's just that Sam is falling behind a bit in math. All you hear is that Sam is failing math.

Or you have a new job and at your first performance review, your boss tells you that you've picked things up much quicker than expected, but perhaps you could make just a few changes to how you file orders. All you hear is that you're filing everything wrong.

What did Peter remember about what Jesus had said? Did he remember "When you return, strengthen your brothers," or was the only thing he remembered "You'll deny you ever knew me"?

Jesus gets us. We see that in the angel's message to the women at the tomb: "Now go and tell his disciples, *including Peter*, that Jesus is going ahead of you to Galilee" (Mark 16:7, emphasis added). If the message had simply been "Go tell the disciples that Jesus will meet them in Galilee," would Peter have gone? Perhaps not. Jesus knew He was ascending back to His Father, and He didn't want to leave any unfinished business with those He loved. Jesus was about to give Peter an opportunity to revisit the moment when he had denied Him three times and cancel out each and every denial. Finally, Friday would make sense.

Jesus Changed Everything

It was a cold night when Jesus was arrested. The smell of smoke was in the air.

Simon Peter followed Jesus, as did another of the disciples. That other disciple was acquainted with the high priest, so he was allowed to enter the high priest's courtyard with Jesus. Peter had to stay outside the gate. Then the disciple who knew the high priest spoke to the woman watching at the gate, and she let Peter in. The woman asked Peter, "You're not one of that man's disciples, are you?"

"No," he said, "I am not."

Because it was cold, the household servants and the guards had made a charcoal fire. They stood around it, warming themselves, and Peter stood with them, warming himself. (John 18:15–18)

Peter and John (according to most commentators) followed Jesus, and because John knew the high priest, he was able to get Peter into the courtyard. Peter stood by those who were warming themselves by a fire. It was a night Peter would never forget. That was Friday and nothing made sense.

Now Jesus was alive again. They'd seen Him twice, but they had no idea what their lives were going to look like now. So the disciples left Jerusalem and returned to Galilee. Still shaken by everything that had happened, Peter decided to do what he knew best. He went fishing.

"We'll come, too," they all said. So they went out in the boat, but they caught nothing all night.

At dawn Jesus was standing on the beach, but the disciples couldn't see who he was. He called out, "Fellows, have you caught any fish?"

"No," they replied.

Then he said, "Throw out your net on the right-hand side of the boat, and you'll get some!" So they did, and they couldn't haul in the net because there were so many fish in it.

Then the disciple Jesus loved said to Peter, "It's the Lord!" When Simon Peter heard that it was the Lord, he put on his tunic (for he had stripped for work), jumped into the water, and headed to shore. The others stayed with the boat and pulled the loaded net to the

shore, for they were only about a hundred yards from shore. When they got there, they found breakfast waiting for them—fish cooking over a charcoal fire, and some bread.

"Bring some of the fish you've just caught," Jesus said. So Simon Peter went aboard and dragged the net to the shore. There were 153 large fish, and yet the net hadn't torn.

"Now come and have some breakfast!" Jesus said. None of the disciples dared to ask him, "Who are you?" They knew it was the Lord. Then Jesus served them the bread and the fish. This was the third time Jesus had appeared to his disciples since he had been raised from the dead.

After breakfast Jesus asked Simon Peter, "Simon son of John, do you love me more than these?"

"Yes, Lord," Peter replied, "you know I love you."

"Then feed my lambs," Jesus told him.

Jesus repeated the question: "Simon son of John, do you love me?"

"Yes, Lord," Peter said, "you know I love you."

"Then take care of my sheep," Jesus said.

A third time he asked him, "Simon son of John, do you love me?"

Peter was hurt that Jesus asked the question a third time. He said, "Lord, you know everything. You know that I love you."

Jesus said, "Then feed my sheep." (John 21:3–17)

As Peter sat on the shore with Jesus, with the smell of a charcoal fire in the air just like on that terrible night when he had denied even knowing Him, once more he was asked three questions.

No longer "Do you know him?" No! No! No!

This time "Do you love me?" Yes! Yes! Yes!

Jesus had changed everything.

Are You Fixed Yet?

One of the questions I get asked more than any other regarding my diagnosis of clinical depression is "Are you fixed yet?" I remember

I'm not fixed.
It's much better
than that.
I'm redeemed.

being a guest on a radio show in Los Angeles, and that was the very first question, "Are you fixed, and how long did it take for them to fix you?" It made me smile. I assured the listener that if I ever was fixed, I'd come back on and let them know. We both laughed, but then I told them that the truth is simple. I'm not fixed. It's much better than that. I'm redeemed, I'm rescued, I'm being held by the One who changed everything, even when I'm standing in the pouring rain, with a flat tire, locked door, and all. You are too. It really is okay not to be okay. You don't have to be perfect. You are perfectly loved just as you are.

Jesus knows you.

He understands you.

He sees your brokenness and will never let you go.

You are being held by the One who changed everything.

If you've been living in a Friday place for a long time, hold on; Sunday is coming!

HOLDING ON
TO HOPE

1. Christ is our hope no matter what happens in this world.

2. Jesus knows you, He understands you, He is holding all the pieces of your story, and He will never let you go.

3. You don't have to be fixed; you're redeemed.

Father God,
Thank You for sending Jesus to take
my place and change my story.
Amen.

10

Let Go! You Are Being Held

He stood me up on a wide-open field;
I stood there saved—surprised to be loved!
GOD made my life complete
when I placed all the pieces before him.

2 Samuel 22:20-21 Message

No matter how devastating our struggles, disappointments, and
troubles are, they are only temporary. No matter what happens to
you, no matter the depth of tragedy or pain you face, no matter how
death stalks you and your loved ones, the Resurrection promises you
a future of immeasurable good.

Josh McDowell

SOMETIMES HOLDING ON and letting go are silent partners . . .
puzzle pieces that surprisingly fit perfectly together. I told you at the
beginning of this book that my husband is an extrovert. I may have
mentioned that at times he asks . . . interesting questions relating to
the possibility of cats smiling. What I didn't disclose, however, is his
obsession with chimpanzees. That became abundantly apparent one
day when we took our son to an amusement park in Florida. I served
at that time on an advisory board with one of the senior officials

at the park, and he had been kind enough to give us special passes to the rides and shows. Christian was especially excited to see the animal actors show. As we took our seats before the show began, a young employee told us that we would be chosen to participate with some of the animals if we were comfortable with that. We assured him we were. It was a great show. A magnificent macaw flew over the audience and landed on Christian's shoulder. He was invited onto the platform to throw balls to two adorable dogs, who could do all sorts of tricks. So far, so good, until the chimpanzee appeared. The trainer asked Barry if he would like to hold Bubbles. I thought he might weep with joy as Bubbles wrapped his arms around his neck and gave him a big kiss on his cheek. The chimp then put his hat on Barry's head and the audience laughed and clapped. Then it was time to give Bubbles back. Barry didn't move. He held on to that chimp as if they were on the *Titanic* and it was going down. The trainer signaled to Barry to bring Bubbles back to the platform. Barry simply waved back. He didn't move. "It's time to give him back," I whispered to Barry. Eventually the trainer pried Barry's arms off his furry new best friend, and he had to let go. On the cab ride back to the hotel, Christian asked his dad, "Did you not know that you would have to give the chimp back, Dad?"

"I did," he said. "I just wanted to hold on a little longer." I know that feeling. When I hug my son before he goes back to grad school, I always want to hold on just a little longer.

But there are times in life we have no choice but to let go of things we thought would always be there. It can be a relationship, a marriage, a home, a career, something we counted on, something we felt defined us. These losses shake us to our core, as if a tsunami has hit our foundation and nothing looks the same anymore.

For me, the loss was something as simple as a ring.

As it was for most of the world, 2020 was financially challenging for us. I usually travel to speak at conferences about twenty-five or thirty weekends a year. When it became clear how fast the virus

was spreading and how infectious it was, all our events were canceled. So, probably like you, we had to make some changes in our lives. Our son's graduate school classes moved online, but tuition still needed to be paid, along with his rent and his car. We sponsor several children overseas and were committed to their future, so we weren't going to stop supporting them. We sat down at our dining room table with a yellow legal pad and a pencil and looked at all our expenses to see what would be the most obvious things to cut. We cut out everything we could. Even as I think about the things we axed, I am very aware that they were minimal sacrifices compared to what many other people were experiencing. For some people, all of life as they knew it changed.

We were doing pretty well, but then we hit a month when things were going to be tight. There were some extra school bills that needed to be paid, and I, unfortunately, incurred some unexpected medical bills. Going downstairs one night in the dark, I fell and fractured four ribs. Not only that, but I broke off one of my front teeth at the gumline. Do you have any idea the difference that one front tooth makes in how you look? Every time I tried to smile in the mirror, I scared myself. I asked my dentist what I would need, and he said I needed a root canal, a post, and a crown. All of this was going to throw our careful budget out the window.

Have you ever been in a similar situation? You're doing fine, and then something unexpected happens and the math doesn't work anymore. The light at the end of the tunnel for us that month was that we had a check coming that had been owed to us for some time. It would more than cover the extra costs. Barry called to check on it and was told it was in the mail. We were relieved and grateful.

We watched and waited for the mail for the next few days, and then I got an email. The note was short and simple: "We're so sorry, but we can't pay you." It was clear that they, like many people, were in a worse place than we were. There was nothing to be said. But we had no idea what we were going to do.

Let Go!

Barry and I sat in silence for a few moments after he read the note. Whenever we'd faced financial challenges in the past, it had always been harder for Barry than for me. He never wants me to worry, so he shoulders the weight of the burden himself. We thought we had been so careful; we had a plan in place, but it didn't take much to dismantle it.

We looked at our options, and there weren't many. We were committed to Christian staying in graduate school, and although he'd offered to get a part-time job to help, he had a full class load, and not only that, but the devastating COVID numbers in his area had made working impossible. I was willing to walk around toothless for a while; after all, I was wearing a mask most of the time, but my dentist said my tooth needed to be fixed or my other teeth would move. *Where would they go?* I wondered. Visions of that were alarming.

As far as I could see, there was one obvious solution. I knew what we needed to do. I also knew that Barry wasn't going to like it.

"I think we need to sell my engagement ring," I said.

"Absolutely not," he responded.

Twenty-seven years ago he had sold his prize possession, a mini grand piano, to buy my ring. It was a beautiful ring, and I loved it. I'll never forget the night he asked me to marry him. He was sweating so badly I thought he had the flu!

"It's the one thing we have that we could part with, and it would give us what we need," I said.

"We're not doing that," he said. "It's your ring."

We talked back and forth for a few minutes and got nowhere. Just considering selling the ring really hurt Barry's heart.

"I'm going to take a drive and get some coffee," I told him. "Just ask God what we should do, and I'll do the same."

I parked in front of my favorite coffee shop, but I didn't go in. I needed to talk to my best friend.

"Lord, you saw this coming. We didn't. We need your help right now. I love my ring, but it's just a ring. What matters to me is the three of us, my husband, my son, and me. In a world that's falling apart, I don't care about houses or cars or rings. I care about You, and You care about us. You love us, and we love each other. That's all the miracle I need. I'm happy to let go of everything else."

I sat for a while in the quiet, praying for my husband. I didn't want him to think that I took his beautiful gift lightly. I just wanted him to understand that I didn't need a diamond to remind me that he loves me; I see it every day in so many little ways, and I would still have my wedding band.

I drove home. Barry was sitting on the sofa in our den, one dog on each side. (What would we do without our dogs when life is hard?) I decided to be very honest.

"Barry, there have been times in our marriage when I needed this ring. I needed it to hold my feet to the fire when things got rough, to remind me of the commitment I made to God and to you. We've been in some tough places over the years, but I don't need this anymore. I can let go of this because God will never let go of us, and we won't let go of each other."

We both shed a few tears that day as Barry drove off with the ring but grateful that we would be able to pay our bills. He came back with a smile on his face and a burden off his shoulders. There was peace in letting go.

If you have found yourself in a much more serious place over the last few months or years, our story might seem ridiculously insignificant compared to what you have lost. If that's true, I am so sorry. It's my prayer that God will show you in ways that are significant and meaningful to you that He is with you. I pray that you will know that He is working in ways you might not see at the moment, that even when you have to let go of something you love, you are being held by the One who loves you and will never let you go.

Only God knows what He is up to in our lives. I think that letting go and holding on work hand in hand. We let go of what we cannot keep to hold on to our Father, who will never let us go. Sometimes He is answering prayers we've been praying for a long time, and sometimes in His kindness and mercy, He lets us see.

God Is Working All the Time

As I was writing this chapter, I received an email from someone I've never met before. His name is Gordon Dasher. The heading on his email was "Your Impact on my Aging Father." He began his note with the sad news that his dad had just passed away a few days earlier from COVID. He was eighty-eight years old. Gordon shared with me some of the issues that he and his dad had struggled with through the years, yet after his dad's passing, he found a note on his father's refrigerator that helped him see that God had been working all along. It was a quote from a book of mine that his dad had typed out and taped where he would see it every day.

I wrote Gordon to thank him for being kind enough to let me know. A few days later, he responded, and I discovered that Gordon is Phil Robertson's brother-in-law. Maybe you know Phil from *Duck Dynasty*. Miss Kay (Phil's wife) is a dear friend of mine, so it was a lovely connection. Gordon writes for one of the family's blogs, and he sent me a piece he wrote about his dad and the faithfulness of God. I asked him if I could share a little of it with you, and he said yes.

> I told him at Thanksgiving that he was a little 12-year-old boy trapped in an old man's body. So, when he called me and told me that he tested positive for COVID, I wasn't worried. And neither was he. We both knew he would beat it. He boasted, "This is no big deal—just a little cough." As soon as he left the doctor's office, he went to the polls and cast his last vote. Then he shopped at Sam's and had his car cleaned

up. But within a week, he was in grave danger. Eventually, my siblings and I had to make the difficult decision to disconnect his life support.

The main reason, however, that I was not ready for him to go was that we had unfinished business. When my mother had fallen and suffered a serious brain bleed a year or so ago, his lifelong desire to take control and find a fix was fanned into flame. She couldn't make a move without him chastising her for doing something dangerous. He became harsh (he would call it "direct") in the way that he spoke to her and others. At first, I was angry with him, but then I began to see his behavior for what it was—he was afraid. He had always been a take-charge guy, but now he couldn't manage what was wrong with Mom. He couldn't fix it, and it was driving him crazy. So, I did what I didn't want to do; I confronted him about it. I challenged him to relinquish control and allow God to manage my mom's welfare. I encouraged him to enjoy his time with her. Yes, I was worried that I would become a casualty of his anger, but he did the unexpected—he listened to me. Still, until the day after his funeral, I didn't know how much he had listened.

When I visited at Thanksgiving, I noticed a quote he had typed out and glued to the refrigerator (I guess he didn't know about magnets). Unfortunately, at the time, I only read the first line: "Be still and know that I am God." I wish now that I had taken the time to read it in its entirety while he was healthy. I wish that I could have told him how proud of him I was. I wish that I had read it before I spoke at his funeral so that I could tell it to the crowd assembled to pay their respects.

The crudely typed quotation (he always typed in capital letters) was from a blogger named Sheila Walsh. I had never heard of her, but I emailed her to thank her. Her words changed my father's life.

Be still and know that I am God. The original Hebrew root of "Be still" doesn't mean "be quiet"; it means "let go." That's very different, don't you think? Let go and know that I am God! Let go of trying to control your spouse! Let go of your worry about your finances! Let go of your unforgiveness! Let go of your past! Let go of what you can't control—and rest in the knowledge that God is in control.

And there it was—all I had ever wanted to know about my dad's heart, and as it turns out, his heart was what I had always hoped it would be. . . . I hadn't been sure that he had listened to me this past summer, but on his fridge for all to see was all the encouragement that I could ever want. He had listened to me—more specifically, he had listened to God. . . .

I saw glimpses of it over the last twenty years or so, but Sheila Walsh's quote will comfort me for the rest of my life because my dad had made it his own. God had spoken to him, and he had listened.[1]

What a gift to a son. I love that Gordon thought I was a blogger, and I love that he'd never heard of me. He was just a kind man who wanted to let a stranger know that she'd touched his dad's life. More than that, I love that God let him see that his father had listened to him and that his father had listened to God. We don't always get those moments in life, but when we do, they are very sweet. He was finally able to see that his dad had found the grace to let go and to be held. At times, that grace comes at the very last minute.

Finally Held

We don't know much about him. We don't even know his name. We don't really know why he was about to be executed. Some translations call him a thief, others a revolutionary. Whatever he'd done, he knew his life was over. I imagine him sleeping very little the night before, knowing what was waiting for him in the morning. Crucifixion is a barbaric way to die. Many of us wear little crosses around our necks. I have one. But to those in the ancient world, that would be as unthinkable as wearing a little electric chair around our necks would be to us. It was the most painful, shame-filled, public way to die. This is Matthew's account of the story.

Two revolutionaries were crucified with him, one on his right and one on his left.

The people passing by shouted abuse, shaking their heads in mockery. "Look at you now!" they yelled at him. "You said you were going to destroy the Temple and rebuild it in three days. Well then, if you are the Son of God, save yourself and come down from the cross!" (Matt. 27:38–40)

The agony of a public execution. The insults were hurled at Jesus, but it was an angry crowd that day, and both revolutionaries were hanging with Him in terrible pain. In Mark's account and John's, all we read about these two men is that they were there, one on each side of Christ. It's Luke who lets us in on a last-minute moment of grace.

One of the criminals hanging beside him scoffed, "So you're the Messiah, are you? Prove it by saving yourself—and us, too, while you're at it!"
But the other criminal protested, "Don't you fear God even when you have been sentenced to die? We deserve to die for our crimes, but this man hasn't done anything wrong." Then he said, "Jesus, remember me when you come into your Kingdom."
And Jesus replied, "I assure you, today you will be with me in paradise." (Luke 23:39–43)

One of these two men was still holding on to his bitterness, his pain, his anger. Even in his final moments he refused to let go of what was tearing him up inside. But what happened to the other man? What did he see in Jesus in the midst of the violence and the pain and the noise? He must have heard the things Jesus spoke from the cross. In the face of a merciless crowd, he heard Him say, "Father, forgive them, for they don't know what they are doing" (Luke 23:34).
Whatever it was that happened to him that day, his eyes were opened and he suddenly realized that he was being executed beside the only man on earth who could save him, not from the death he was facing but for all eternity. Can you imagine what that realization must have been like? Think about it. You've ruined your life. You've

made bad choice after bad choice, and you've been caught. There is nothing you can do to save yourself. Your life is over, and then, suddenly, you turn your head and you are looking into the eyes of the Son of God, who is dying beside you. When he asked Jesus to remember him when He came into His kingdom, the man had no idea just how quickly that was going to happen.

Theologians argue over whether there should be a comma after "today," as in "I assure you today, you will be with me in paradise." Or should it be, "I assure you, today you will be with me in paradise." As far as I'm concerned, it doesn't matter a hill of beans. This man, with no time left to live a good life or redeem himself, called on the name of the Lord, and he was saved!

It's never too late to turn your head and look into His eyes and be saved.

God is a redeemer.

The One Who Is Holding All Your Pieces

I remember picking apples with my friends when I was about ten years old. I was a good climber, so I was the one up the tree throwing the apples down for my friends to catch. I saw a few perfect ones on a branch a little farther out than I'd gone before, but they looked so good I decided to go for it. As I crept out onto the branch, it began to crack, and I realized I was going to fall. One of my friends told me to let go and that she would catch me. As much as I loved her, she was no more than about sixty-five pounds soaking wet. "Anyone else down there?" I shouted, and Garry, one of my brother's friends, came to the rescue.

When you're being told to let go, you need to know that the one who is telling you to let go can catch you. You won't let go unless you are totally convinced that you will be caught, that you will be held. I want you to know that when God invites you to let go, you can be sure you will be held.

Warren Wiersbe wrote, "The safest place in all the world is in the will of God, and the safest protection in all the world is the name of God. When you know His name, you know His nature."[2]

We've talked about many things in this book, things that would bring us to our knees, things that would make us want to let go. We've looked at some of the ways we are being held, but I didn't want to end this book without helping you catch a fresh vision of the greatness of God our Father and of our Savior, Jesus Christ. Until we are finally home, there will still be mystery and unanswered questions, but He has revealed so much to us through His names. As Wiersbe wrote, *when you know His name, you know His nature.*

Psalm 23 has been one of my favorite psalms since I was a child. Some think David wrote this when he was just a young shepherd boy, but there is something about the wisdom in it and the sense of having lived life long enough to know how hard it can be that makes me wonder if David wrote it later in life. I have read the Word of God over and over, and what amazes me is that I know I've hardly begun to plumb the depths of its wealth and mystery. Within this well-loved psalm, I discovered something I'd never seen before. Did you know that at least ten of the names of God are hidden in this one psalm alone? Let's take a look at some of those names because I want you to know whose arms you are falling into. He is

Your Shepherd

Your Provider

Your Peace

Your Healer

Your Righteousness

Your Help

Your Victory

Your Sanctifier

Your Portion

Your Inheritance[3]

No matter what is going on in your life right now, you are being held in the arms of the One who is everything you need.

1. Jehovah-Raah *(the Lord my shepherd)*. *"The* LORD *is my shepherd" (v. 1).*

This is one of the most powerful and personal names of God. It is one of my very favorites because it is so tender and so loving. Shepherds in Israel loved their sheep. They gave each one a name. Each day, the shepherd would go ahead of his flock to make sure the path was clear, that there was no danger ahead. He would count each one at night as they came into the pen to make sure no one was missing. When they were all gathered in, he would sleep in front of the opening. The message was clear: "If you want to get to the sheep, you'll have to come through me!" That's who Christ is for each one of us. He knows your name and watches over you day and night.

2. Jehovah-Jireh *(the Lord my provider)*. *"I have all that I need" (v. 1).*

The first time this name is used for God is in Genesis 22. It's one of the hardest stories to read as a parent. Abraham and Sarah had longed for a child for so many years. It seemed impossible, but then God intervened. Sarah was ninety years old when she gave birth to their promised son, Isaac. Then God asked Abraham to sacrifice Isaac. Can you imagine how painful that must have been? We don't know how old Isaac was at the time, but trusted biblical scholars agree that he wasn't a little boy, that he was anywhere between twenty and thirty years old. He had to be strong enough to carry the sufficient amount of wood up a mountain to fully consume a human body. Abraham, by faith, trusted God. He was being tested to see if

No matter what is going on in your life right now, you are being held in the arms of the One who is everything you need.

he truly trusted God's promise that, through this young man, Abraham's descendants would be as numerous as the stars. As Abraham was about to plunge the knife into his son, God stopped him. Then Abraham saw a ram whose horns were caught in the thicket, and the ram became the sacrifice. We read in Genesis 22:14, "Abraham named the place [Jehovah-Jireh] (which means 'the LORD will provide')."

This was a foreshadowing of the truth that just as the ram took Isaac's place, Christ would be the provided Lamb as the perfect sacrifice for us.

3. Jehovah-Shalom *(the Lord my peace)*. "He lets me rest in green meadows" *(v. 2)*.

The first time this name appears in the Bible is in Judges 6. The angel of the Lord appeared to a young man named Gideon and told him that he would be the one to deliver his people from their enemies. Gideon was terrified and asked for a sign that the messenger was really from God. He asked the angel (not realizing that this was actually an Old Testament appearance of Christ) to wait until he could come back with a meal (not a pizza, mind you—a whole goat!). When Christ touched the meal with the tip of His staff, fire consumed it all, and He disappeared. When Gideon realized that he'd been talking to the angel of the Lord, he was sure he was going to die. The Lord told him that he was not going to die. So Gideon built an altar and named it Jehovah-Shalom—the Lord is peace. Christ's presence was peace to Gideon that day, and He offers that same peace to you today.

4. Jehovah-Rophe *(the Lord my healer)*. "He renews my strength" *(v. 3)*.

That name, Rophe, or Rapha, means "The Lord is my healer, physically and spiritually." The thing that is so fascinating about this name is that unlike Jehovah-Jireh or Jehovah-Shalom, where God's people gave Him a name, it was God Himself who revealed

this name to the children of Israel. He told them that He is Jehovah-Rophe after they'd crossed the Red Sea.

For I am the LORD who heals you. (Exod. 15:26)

On the cross, that healing was perfected.

But he was pierced for our rebellion,
crushed for our sins.
He was beaten so we could be whole.
He was whipped so we could be healed. (Isa. 53:5)

5. Jehovah-Tsidkenu *(the Lord is our righteousness).* "He guides me along right paths, bringing honor to his name" (v. 3).

The prophet Jeremiah, looking ahead to the day that Jesus, our Messiah, would come to save His people, wrote,

In those days and at that time
I will raise up a righteous descendant from King David's line.
He will do what is just and right throughout the land.
In that day Judah will be saved,
and Jerusalem will live in safety.
And this will be its name:
"The LORD Is Our Righteousness." (33:15–16)

No matter what you've done, no matter how often you have failed or fallen down, when Christ is your Savior, He alone is your righteousness. He makes you right with God.

6. Jehovah-Ezer *(the Lord is my help).* "Your rod and your staff protect and comfort me" (v. 4).

We put our hope in the LORD.
He is our help [Ezer] and our shield. (Ps. 33:20)

I love the way Charles Spurgeon fleshes that out.

> Men can come to our help, but they travel slowly, creeping along the earth. Lo, our God comes riding on the heavens. They who travel on the earth may be stopped by enemies, they certainly will be hindered; but he that rides upon the heavens cannot be stayed nor even delayed. When Jehovah's excellency comes flying upon the sky on the wings of the wind, how gloriously are displayed the swiftness, the certainty, and the all-sufficiency of delivering grace. God has ways to help us that we dream not of.[4]

7. Jehovah-Nissi *(the Lord my standard of victory)*. "You prepare a feast for me in the presence of my enemies" (v. 5).

The full meaning of this name can be hard to grasp. Clearly we're not at an all-you-can-eat buffet, surrounded by enemies. So what does it mean?

In Exodus 17:15 we read, "Moses built an altar there and named it [Jehovah-Nissi] (which means 'the LORD is my banner')."

Moses, Joshua, and the children of Israel were in a fierce battle with a hostile desert tribe. They were constantly crossing land where they were not welcome, and they had to fight for their survival.

> Meanwhile, Moses, Aaron, and Hur climbed to the top of a nearby hill. As long as Moses held up the staff in his hand, the Israelites had the advantage. But whenever he dropped his hand, the Amalekites gained the advantage. Moses' arms soon became so tired he could no longer hold them up. So Aaron and Hur found a stone for him to sit on. Then they stood on each side of Moses, holding up his hands. So his hands held steady until sunset. As a result, Joshua overwhelmed the army of Amalek in battle. (Exod. 17:10–13)

Remembering how God has delivered us in the past is a wonderful spiritual discipline. You might want to find a little stone and write

a word or a date on it to remind you that God delivered you once and He can do it again.

8. Jehovah-M'Kaddesh *(the Lord who sanctifies me)*. *"You honor me by anointing my head with oil" (v. 5).*

In the Old Testament, the children of Israel had 613 laws that they had to keep to be holy in God's sight. There were 365 don'ts and 248 dos.

> So set yourselves apart to be holy, for I am the LORD your God. Keep all my decrees by putting them into practice, for I am the LORD who makes you holy. (Lev. 20:7–8)

Can you imagine the burden of waking up every day with 613 laws to keep? But for us, it is Christ who makes us holy.

> Now he has reconciled you to himself through the death of Christ in his physical body. As a result, he has brought you into his own presence, and you are holy and blameless as you stand before him without a single fault. (Col. 1:22)

We're not saved by trusting in our own goodness or holiness. We are saved by trusting in His.

9. Jehovah-Manah *(the Lord is my portion)*. *"My cup overflows with blessings" (v. 5).*

Over and over, the writers of the Psalms say, "The Lord is my portion."

In Psalm 73:25–26 we read,

> Whom have I in heaven but you?
> And earth has nothing I desire besides you.

It's the cry of praise from David's heart to the One who held him and all the pieces of his story.

> He stood me up on a wide-open field;
>> I stood there saved—surprised to be loved!
> GOD made my life complete
>> when I placed all the pieces before him. (22:20–21
>>> Message)

Will you do that? Will you lay all the broken pieces before Him and let Him do what only He can do? He will put some of them back in place and some, like my ring, you won't need anymore.

It's the cry of praise from David's heart to the One who held him and all the pieces of his story.

> He stood me up on a wide-open field;
> I stood there saved—surprised to be loved!
> GOD made my life complete
> when I placed all the pieces before him. (22:20–21
> Message)

Will you do that? Will you lay all the broken pieces before Him and let Him do what only He can do? He will put some of them back in place and some, like my ring, you won't need anymore.

God made
my life complete
when I placed
all the pieces
before Him.

My flesh and my heart may fail,
 but God is the strength of my heart
 and my portion forever. (NIV)

I want to live like that. I want to live with total devotion to Christ, soaking my life in the truth of His Word. Whatever you feel as if you're lacking today, the Lord is your portion.

10. Jehovah-Cheleq *(the Lord my inheritance).* "Surely your goodness and unfailing love will pursue me all the days of my life, and I will live in the house of the LORD forever" *(v. 6).*

We find this name of God in Deuteronomy 18:2. When the land God gave to His people was divided among the tribes of Israel, the only tribe that received no land was the Levites. They were the ones who led in worship, and this is what God said about them:

They shall have no inheritance among their fellow Israelites; the LORD is their inheritance, as he promised them. (NIV)

I love that. What a gift to those who led in worship. Now that gift is for everyone who trusts in Christ. The Lord Himself is our inheritance.

I pray that the eyes of your heart may be enlightened in order that you may know the hope to which he has called you, the riches of his glorious inheritance in his holy people, and his incomparably great power for us who believe. (Eph. 1:18–19 NIV)

I know that life can be so hard with so many unanswered questions, but we are never alone or abandoned. Our God is a rescuer, a deliverer, a tender Shepherd. We can let go because we are being held. At the beginning of this chapter we read a passage from 2 Samuel.

a word or a date on it to remind you that God delivered you once and He can do it again.

8. Jehovah-M'Kaddesh *(the Lord who sanctifies me).* "You honor me by anointing my head with oil" *(v. 5).*

In the Old Testament, the children of Israel had 613 laws that they had to keep to be holy in God's sight. There were 365 don'ts and 248 dos.

> So set yourselves apart to be holy, for I am the LORD your God. Keep all my decrees by putting them into practice, for I am the LORD who makes you holy. (Lev. 20:7–8)

Can you imagine the burden of waking up every day with 613 laws to keep? But for us, it is Christ who makes us holy.

> Now he has reconciled you to himself through the death of Christ in his physical body. As a result, he has brought you into his own presence, and you are holy and blameless as you stand before him without a single fault. (Col. 1:22)

We're not saved by trusting in our own goodness or holiness. We are saved by trusting in His.

9. Jehovah-Manah *(the Lord is my portion).* "My cup overflows with blessings" *(v. 5).*

Over and over, the writers of the Psalms say, "The Lord is my portion."

In Psalm 73:25–26 we read,

> Whom have I in heaven but you?
> And earth has nothing I desire besides you.

213

HOLDING ON
TO HOPE

1. In difficult places and apparently hopeless situations, we can say, "This looks impossible, *but God.*"

2. The missing pieces of your story are in the safest hands of all—Jesus's.

3. It is safe to let go—He is holding you.

Father God,
Thank You that You hold all the pieces
of my story and that You hold me.
Amen.

Conclusion

LOST THINGS CAN TURN UP when we least expect them. Not long ago, I found the missing piece of a lion jigsaw puzzle I was given for Christmas two years ago. It was at the bottom of my dog's toy basket. I remember tearing up the house looking for it, as it was not just the last piece but a key piece. We didn't find it, so we had a lion with half an eye missing. The piece wasn't really worth saving now, as it had been chewed into a shape of its own and wouldn't fit in place. I've discovered that's not true, though, when God puts a missing piece in place. No matter how long it's been missing, it fits just perfectly.

There had been a piece missing from my heart for a long, long time, and I never thought I'd get it back, certainly not on this earth. It wasn't something I had told anyone about, not even Barry. It was too painful, but in God's perfect time, He gave it back to me.

It had always been a heartache to me that my dad was buried in an unmarked grave in the small town in Scotland where he was born. The circumstances of his death were regarded as shameful back then. He went from being a respected deacon of the small church we attended as a family to being committed to an asylum to dying by drowning in a river. After his death, we left that town, never to return. I tried to find the unmarked spot where he was buried several

times over the years, but I couldn't find it. I made peace with that ache until we buried my mum. She was buried in a beautiful cemetery beside her mother and father. I flew home for her funeral and stayed a few days to help my sister go through mum's things. Then I flew back to Dallas. Several weeks later, my sister sent me a picture of the gravestone. It was lovely. I read the names:

In Loving Memory of
Alexander Nicol,
His wife, Margaret
And their daughter, Elizabeth Walsh.
Much loved parents and grandparents.
At Peace with the Lord.

It was a beautiful memorial, but everything inside me screamed, "Where's my dad?!" I knew that he was home, safe with the Lord, but it felt as if his memory had been erased from this earth. I wrote his name in my Bible and left my heartache with the Lord.

My sister, brother, and I don't talk about my dad; the events of our childhood are very painful. Even when I flew home twice to try to find his grave, I didn't tell them. I went alone.

Years had passed, but God was working behind the scenes. God is always working.

Two years ago, my sister was staying with us while my brother-in-law was off golfing with friends. One night she asked me a question. She asked if there was anything she could ever do for me. Her question was so intentional. I hesitated for a moment. I didn't want to upset her. Finally, I said, "Do you think you could help me find out where Dad is buried?"

She said, "Sheila, I know where he's buried. I have the papers."

It's hard to put into words what finding him meant to me or the pure joy I felt when my sister, brother, and I raised a stone in his memory.

Hold on to Jesus with everything that's in you, and on the days when you feel yourself slipping, remember that you are being held.

In Loving Memory of
Frances McGrady Walsh
Much loved husband of Elizabeth Walsh
And father to Frances, Sheila, and Stephen

I don't know what the missing pieces in your story are. I don't know the circumstances you find yourself in right now or why you might feel as if you are just clinging to hope by a thin thread. But I do know this:

You are not alone.

You are not abandoned.

You are seen.

You are loved.

You are believed.

You are forgiven.

You are free.

Hold on to Jesus with everything that's in you, and on the days when you feel yourself slipping, remember that you are being held.

God gave Moses a blessing for his brother, Aaron, to pray over God's people. May I pray it over you . . .

> May the LORD bless you
> and protect you.
> May the LORD smile on you
> and be gracious to you.
> May the LORD show you his favor
> and give you his peace. (Num. 6:24–26)

Acknowledgments

FIRST OF ALL, thank you to the entire Baker Publishing family. Dwight Baker, you and your team continue to uphold the rich heritage of Baker's commitment to building up the body of Christ through books. It's an honor to publish with you.

Thank you to my wonderful editor, Rebekah Guzman, and the entire editorial team. I'm grateful for your vision and your hard and creative work. The year 2020 was a tough year to write a book, but by God's grace we got it done!

Thank you to Mark Rice and Eileen Hanson. I love working closely with both of you, and when you fly into Dallas for dinner, that's the best. You make me laugh and you make me think, and you are so good at what you do.

Thank you to Dave Lewis and the amazing Baker sales team. You have such a gift for understanding the heart of a message and championing it.

Thank you to Brianna DeWitt and Olivia Peitsch. You are always looking for new ways to get the message out. I'm so grateful for you.

Thank you to Laura Palma and Patti Brinks for your caring and creative artistic direction and your endless patience with me. You are a joy to work with.

Thank you to Brandon Hill. I am not a huge fan of having my photo taken, but you made it pure joy.

Thank you to my amazing literary agent, Shannon Marven. Shannon, you are one of the most gifted people I know. You lead with grace, compassion, and vision. Thank you to Rebecca Silensky and the entire team at Dupree Miller.

Thank you to Caleb Peavy and Unmutable. I am grateful for your creativity and the level of excellence you bring to every project.

Thank you to James and Betty Robison for the joy of standing beside you to share God's love with a broken world through *Life Today* and Life Outreach International.

I want to thank my little dogs, Tink and Maggie, for sitting patiently at my feet month after month as I wrote and for the occasional much-needed lick.

To my husband, Barry, thank you seems inadequate to express my gratitude for the amount of time and creative energy you devoted to this book. You walked and prayed through every step with me, sitting up until midnight reading chapters out loud, making countless cups of tea. I love you and thank God for you every day.

To my son, Christian. Your FaceTime calls and texts to cheer me on meant so much. I love being your mum.

Finally, to the One I will never find enough words to thank. To God my Father for loving me, to Christ my Savior for giving Your life for me, and to the Holy Spirit for Your comfort and guidance. I am Yours, forever. I am held.

Notes

Chapter 2 Holding On When You Feel Alone

1. Thomas Hardy, *Tess of the d'Urbervilles* (Toronto: HarperCollins, 2017), 312, Kindle.

2. Kathie Lee Gifford, with Rabbi Jason Sobel, *The Rock, the Road, and the Rabbi* (Nashville: Thomas Nelson, 2018), 128, Kindle.

Chapter 3 Holding On When God Is Silent

1. Philip Yancey, *Disappointment with God* (Grand Rapids: Zondervan, 1988), 163.

2. "IRAN: 'Jesus Is Walking in the Streets of Iran,'" Church in Chains, September 18, 2015, https://www.churchinchains.ie/news-by-country/middle-east/iran/iran-jesus-is-walking-in-the-streets-of-iran/.

3. Warren W. Wiersbe, *Be Patient* (Colorado Springs: Chariot Victor Publishing, 1991), 19.

4. Charles R. Swindoll, *Great Lives: Job* (Nashville: Thomas Nelson, 2004), 34, Kindle.

5. Warren W. Wiersbe, *The Wiersbe Bible Commentary* OT (Colorado Springs: David C. Cook, 2007), 867, italics in original.

6. Friar Luke Veronis, "The Sign of the Cross" (sermon, St. George's Church, Durres, Albania, March 19, 2017).

Chapter 4 Holding On When You're Afraid

1. Deepa Narayan, "India Is the Most Dangerous Country for Women. It Must Face Reality," *The Guardian*, July 2, 2018, https://www.theguardian.com/commentisfree/2018/jul/02/india-most-dangerous-country-women-survey.

2. John Phillips, *Exploring Psalms*, vol. 1, John Phillips Commentary Series (Grand Rapids: Kregel, 2002), 435.

3. "Tetelestai—Paid in Full," Precept Austin, updated May 28, 2018, https://www.preceptaustin.org/tetelestai-paid_in_full.

Chapter 5 Holding On When You've Messed Up

1. Sheila Walsh, *Honestly* (Grand Rapids: Zondervan, 1996), 66.
2. Timothy Keller, *The Reason for God* (New York: Riverhead Books, 2008), 166.
3. Søren Kierkegaard, quoted in Keller, *The Reason for God*, 168.
4. Timothy Keller, "Sin Quotes," GoodReads, accessed February 3, 2021, https://www.goodreads.com/quotes/tag/sin.
5. C. S. Lewis, *Mere Christianity* (New York: HarperOne, 2015), 197–98, Kindle.
6. Lewis, *Mere Christianity*, 196, Kindle.

Chapter 6 Held by the Promises of God

1. David Jeremiah, *The Jeremiah Study Bible* (Nashville: Worthy Publishing, 2016), 1763.
2. Jeremiah, *The Jeremiah Study Bible*, 1551.
3. Warren W. Wiersbe, *Be Obedient: Learning the Secret of Living by Faith*, 2nd ed. (Colorado Springs: David C. Cook, 2010), 15, italics in the original.
4. C. S. Lewis, *Prince Caspian: The Return to Narnia* (Nashville: Harper-Collins, 1994), 141.

Chapter 7 Held by the God Who Rescues

1. Natalie Grant, vocalist, "Held," by Christa Wells, recorded March 22, 2005, track 9 on *Awaken*, Curb Records.
2. Vaneetha Rendall Risner, interview with the author, February 4, 2021.
3. Vaneetha Rendall Risner, *Walking Through Fire* (Nashville: Thomas Nelson, 2020), 252.
4. "Being Still," Bible Reasons, January 8, 2021, https://biblereasons.com/being-still/.
5. "Being Still."
6. *HarperCollins Bible Dictionary*, s.v. "faith," rev. ed. (New York: HarperCollins, 2011), 280.

Chapter 8 Held by the God of Miracles

1. "Our Impact," Wycliffe Bible Translators, accessed February 3, 2021, https://www.wycliffe.org.uk/about/our-impact/.
2. Augustus Montague Toplady, "Rock of Ages," 1763, public domain.

Chapter 9 Held by the One Who Changed Everything

1. Joseph Lenard, "Jesus' Birth—The Case for Migdal Edar," Truth in Scripture, January 21, 2017, https://truthinscripture.net/2017/01/21/jesus-birth-the-case-for-midal-edar/.
2. Gifford with Sobel, *The Rock, the Road, and the Rabbi*, 37.
3. Wiersbe, *The Wiersbe Bible Commentary OT*, 661.

4. Angie Smith, *Matchless: The Life and Love of Jesus* (Nashville: Lifeway Press, 2020), 74.

5. John Calvin, *A Harmony of the Gospels of Mathew, Mark and Luke*, vol. 3, Calvin's NT Commentaries (Grand Rapids: Eerdmans, 1991), 197.

6. Martin Luther, *Lectures on Galatians*, Luther's Works, vol. 26 (St. Louis: Concordia, 1963), 277.

Chapter 10 Let Go! You Are Being Held

1. Gordon Dasher, "I Had Unfinished Business with My Dad. Then I Found His Message From Beyond the Grave," *Al and Lisa Robertson* (blog), January 13, 2021, https://alandlisarobertson.com/i-had-unfinished-business-with-my-dad-then -i-found-his-message-from-beyond-the-grave/. Used by permission.

2. Warren W. Wiersbe, "Safest Protection in the World," oChristian Articles, accessed March 23, 2021, http://articles.ochristian.com/article10227.shtml.

3. Shari Abbott, "The Names of Jehovah Hidden in Psalm 23! This Will Surprise You!," Reasons for Hope* Jesus, April 20, 2016, https://reasonsforhopejesus.com /names-jehovah-hidden-psalm-23/.

4. Charles H. Spurgeon, "Israel's God and God's Israel," (transcript of sermon no. 803, Metropolitan Tabernacle, Newington, London, March 29, 1868), 4.

About the Author

Sheila Walsh grew up in Scotland and has spoken to over six million women around the world. Her passion is being a Bible teacher, making God's Word practical, and sharing her own story of how God met her when she was at her lowest point and lifted her up again. Her message: GOD IS HOLDING YOU! Sheila loves writing and has sold more than five million books. She is also the cohost of the television program *Life Today*, airing in the US, Canada, Europe, and Australia, with a potential audience of over one hundred million viewers daily. Calling Texas home, Sheila lives in Dallas with her husband, Barry, and two little dogs, Tink and Maggie, who rule the roost. Sheila and Barry's son, Christian, is in graduate school in Texas.

CONNECT WITH SHEILA

For more encouragement and free resources, visit
SHEILAWALSH.COM

· ·

 SheilaWalsh1 SheilaWalshConnects SheilaWalsh

YOU'RE NOT ALONE.
GOD IS LISTENING.

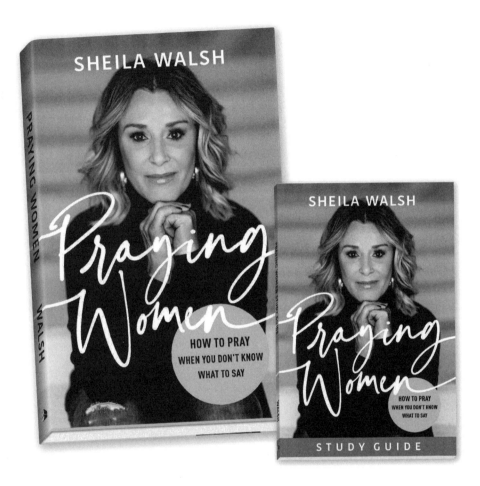

Prayer changes you, and it changes the world. You may have tried before, but if you're ready to start again in your relationship with God, let Sheila Walsh show you step-by-step how to become a strong praying woman.

JUMP-START HER PRAYER JOURNEY

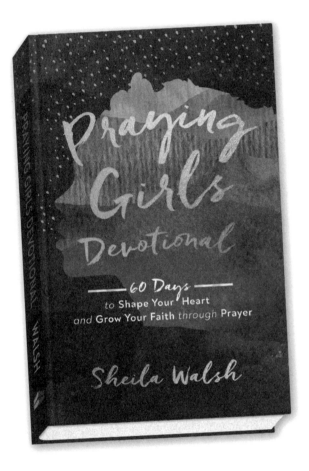

In *Praying Girls Devotional*, bestselling author
Sheila Walsh offers you an exciting guide to begin
a life of prayer. Perfect for girls ages 11–14.

Watch Sheila!

Tune in to watch Sheila on *Life Today*

Sheila Walsh shares insights and revelation from the Bible as she studies God's Word and discusses what He has put on her heart.

VISIT

SheilaWalsh.com/watch-sheila
OR
LifeToday.org